THE ART OF JIM WARREN

Written by: **Jim Warren** and **Jane Taylor Greenberg**

Designed by: **Jim Warren**

Layout & Computer-graphics: **Dan Swanson**

Special thanks to...

My parents, who gave me the name which graces the cover of this book, and who gave me my first paint set, along with the support and encouragement to use it. My wife, Cindy, who doubles as my art director; my daughter, Drew; my step-daughter, Rebecca; my son, Art; and to all the rest of my family and relatives near and far whose love and support have driven me. All of my associates who take care of business so that I can paint: Paul Missonis, my agent and publisher, and president of Art Lover Products, Inc., and his hard-working crew; Wyland, who has helped preserve marine life and brought excitement into the world of art; Darlene Wyland, Bill Wyland, and to all of the dedicated staff of the Wyland Galleries; Alan Lynch, my New York art representative for illustration; and Jane Frank of Worlds of Wonder Gallery. Dyke Ferrell and Mike "Merc" Mercadante of Planet Ocean for their special support. Dick Lyday of Heritage Graphics, Inc., for his invaluable assistance, and for going that extra mile. Richard and Judy Weigand, my business consultants. Ron King, John Tyselling, Ed Kenedy, and Angela Eaton for their help. My personally hand-picked creative team from Clearwater, Florida: Jane Taylor Greenberg and Dan Swanson. My fellow artists whom I tour with: Wyland, Coleman, Walfrido, Maiden, Pitre, Hanson, Deshazo, Stewart, and The Leungs. All of my friends, who often become my collectors, and to all my collectors who often become my friends. My models who are the stars of my paintings. My fans of all ages. And to L. Ron Hubbard for inspiring me to achieve my goals.

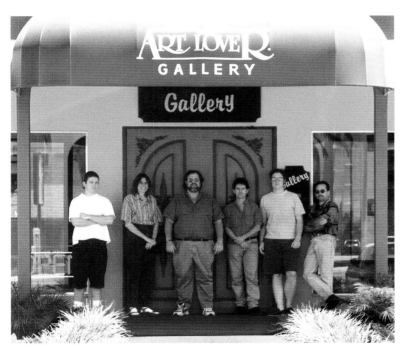

Jim (4th from left) with the crew of Art Lover Products, Inc. Clearwater, Florida, 1997, Grant, Molly, Paul, and Russell Missonis; and Stan Wilson

Creative team: Jane Taylor Greenberg, Dan Swanson, and Jim Warren

Jane Taylor Greenberg is a freelance writer who lives in Clearwater, Fl. with her husband and children. Dan Swanson of Van-garde Imagery is a computer-graphic artist who lives in Clearwater, Fl. with his wife and children.

This book published by Art Lover Products, Inc. in association with Jim Warren Studios, 625 S. Missouri Ave, Clearwater, FL 33756.

ISBN 0-9658775-0-7
Library of Congress Catalog Card No. 97-073443

Print Director: Dick Lyday, Heritage Graphics, Inc.

Printed and bound in Hong Kong
by Everbest Printing Co., Ltd.

Contents

One In the Beginning 7

Two Fine Art 21

Three Collaborating with Wyland 75

Four Portraits 83

Five Illustration 97

Six Jim Shares His Magic 119

"People often ask me if I was an artist as a child. I answer, 'Everyone is an artist as a child. Some of us just never stopped!'"

Jim Warren

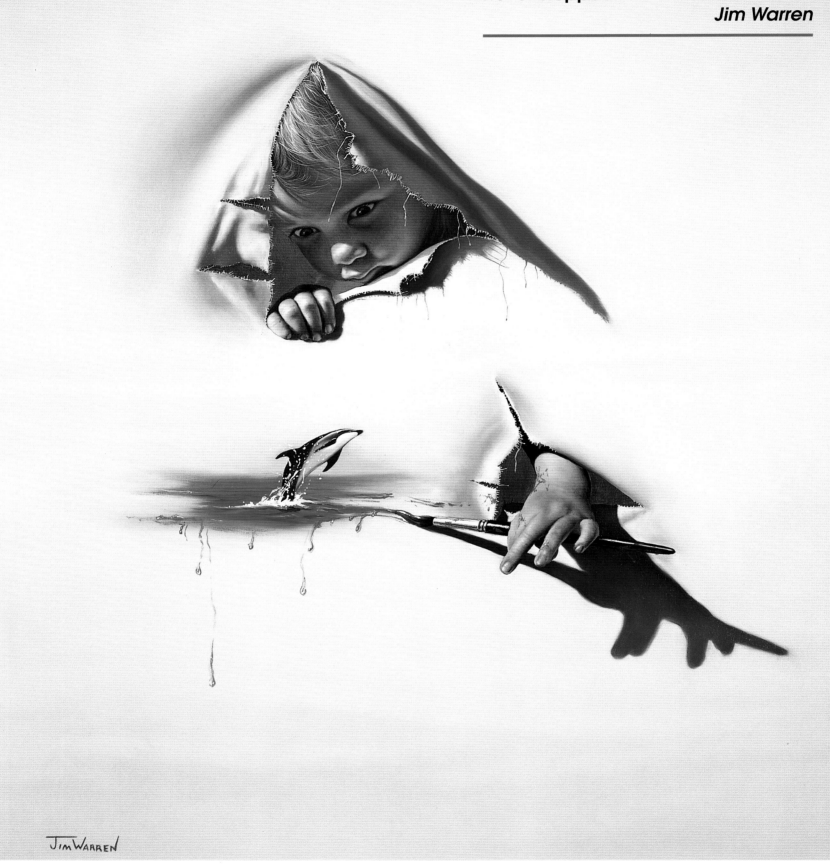

Imagine

Introduction by Wyland

For thirty years, Jim Warren has been painting his way into the collective consciousness of people the world over. Self-taught, he developed his own style of surrealistic fantasy and has been compared to Salvador Dali, Norman Rockwell and many other fine artists. But the truth is that Jim is an American original.

I first became aware of his work in 1978 when I saw a few of his now classic paintings. Like most people, I was mesmerized by his pure talent, but was even more amazed by his imagination. I realized even then that Jim was unique in the world of art. What was this guy thinking? Who was this person who could come up with those zany subjects and endless ideas which grabbed our attention and opened up our minds?

Several years later when Jim and I were both featured at the Los Angeles Art Expo, I had the privilege of meeting him. As I got to know him, I was surprised to find that he was just a regular guy from California. He was proud of his family and they, in turn, supported his art. At the time, I had no idea of the scope of his painting or his range of subject matter.

Jim won a Grammy for his album cover for Bob Seger's "Against the Wind" and has added to that numerous other awards and accolades. His images grace the covers of numerous books and magazines internationally. Clive Barker and Arthur C. Clarke are just two authors whose books display his work.

At Wyland Galleries, where we feature his art, he receives more attention than all of our artists combined. Each of his amazing paintings means something totally different to every viewer. He never duplicates himself and is now focusing on his "Beauty of Nature" series and his unique portraits which are, clearly, another example of the originality of Jim Warren.

When I, myself, commissioned him to paint a cover for my biography, "Whale Tales," he captured the spirit of my life's work. He began the cover for my book by photographing me in unusual poses which only Jim could understand.

His models are family members, friends, or sometimes even neighbors. He invites the people in his paintings to attend our Wyland Gallery shows, and when they arrive, it's as if they've stepped off of the canvas and onto the gallery floor. The effect is that of a fantastic living art show which is classic Jim Warren.

In this first book featuring Jim Warren's work, he shares his amazing art with us and offers us insight into a living legend of the art world.

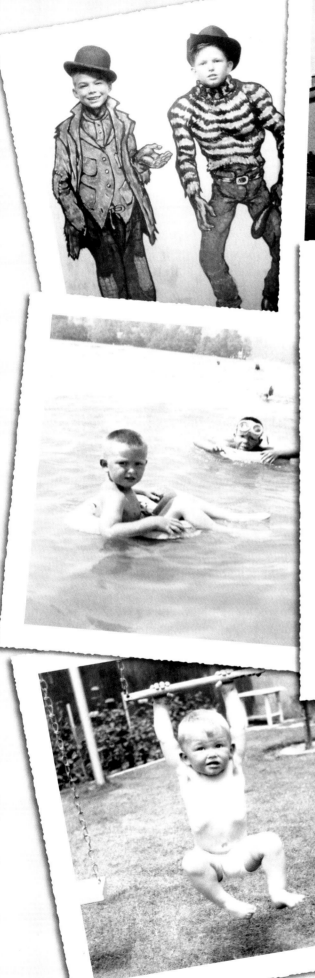

In the Beginning

by Jane Taylor Greenberg

Jim Warren began his life in what was then the sleepy little town of Long Beach, California, on the twenty fourth of November, 1949. He was the third child of Don and Betty Warren. His sister, Kathy, was five years old, and brother, Rick, was two.

The country was at peace, having just won the war four years before, and America's attention was off of Europe and onto building strong family units, with father working a good job and mother providing a clean, happy home and raising her children. Grandparents visited often, and many Americans spent Sunday mornings in church. At the Warren house, life was just such an example of this, with Don working as a supervisor at Ford Motor Company, and Betty busy taking care of the Warren household and children.

Radio brought families together for exciting weekly entertainment. Something called "television," was a laboratory concept. The computer age slept deeply, alive only in the dreams of scientists and science fiction writers.

In the calm of the next few years, in this warm, unpretentious setting, Jim played with his sister and brother and his dog, Sissy. At five o'clock sharp each day, Mom was on the front porch, gathering her children with a loud, "Dinner's ready! Come eat!" The Warren family would have been an ideal subject for the then enormously popular artist, Norman Rockwell. As Jim

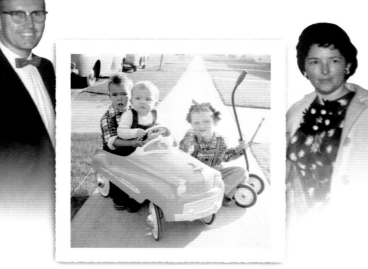

grew, science and technology advanced. The magic box, "television," emerged and quickly replaced radio as the major form of entertainment. Families gathered to watch "The Ed Sullivan Show" and "Leave it to Beaver." And, in fact, Jim's life was not far removed from that of "The Beaver" himself.

At seven, Jim decided to become an artist. He had been drawing in school, and one day he spotted a magazine ad for a drawing contest. Contestants were asked to copy a cartoon. Jim was nervous, anticipating tough competition, but a month later a man arrived at the Warren's house to tell Jim that he had won the contest and a free art class! Jim's Dad thanked the man, but told him that Jim had decided on a new career. He wanted to be a magician.

To help him with his new career, his parents drove the budding magician to Hollywood to visit the famous Hollywood Magic store where he bought ready-made magic tricks. But, in his creative style, Jim began making his own magic tricks out of wood, painting them and then using them to present shows to his family and friends.

But, by the age of ten, Jim's attention returned to art. By this time, his artistic creativity had turned toward the more exotic. One day, looking down at the drab, gray driveway outside the Warren home, he suggested to his parents that they liven it up by painting it with bright colors. Though his parents

declined, Jim was not discouraged, and soon after, when he began to notice the opposite sex, he decided that the perfect way to attract girls would be to color his hair blue, which he proceeded to do. In the safe environment provided for him by his parents, Jim's irrepressible imagination knew no bounds.

As he moved into his teen years, he spent most of his free time at the beach. The sixties saw the emergence of the

7th through 10th grades

California surf culture, accompanied by the clothes and hairstyles of that era, and rock music heralding the onslaught of a strange, powerful new problem for America—drugs.

Jim entered Jordan High School in Long Beach and found himself over-whelmed by the pressures of high school and the confusion of the sixties. In his tenth grade art class, the environment began influencing Jim's drawings. Most of what he drew was guitars. Reminiscing about this era, Jim says, "I bought an electric guitar and spent hours in front of the mirror with it. But, then I thought of performing on a real stage in front of people and got stage fright just thinking about it." Because school was not his favorite pastime, Jim drew pictures in class instead of studying. He idolized many rock bands of the era and dreamed of having his art on their album covers.

But he was becoming disenchanted with art. He was bored by the limitations of the form as given to him by teachers. The turning point came in 1966, when Jim was in the tenth grade. He was at home, thumbing through Life magazine. Turning the page, his eyes froze on the art of Salvador Dali. Looking at these paintings, he realized that his art could be anything he wanted. "You can paint nature, people, something completely wild, or any combination of subjects," he said to himself. About that experience, Jim says, "I knew then that I wanted to be an artist. I decided to do whatever it took to do that. I loved Dali's weirdness and surrealistic images, but what really inspired me was how someone could paint whatever they wanted, with no barriers, no rules. Before that moment, I had the idea that art had fixed guidelines, like plumbing. That's why my enthusiasm had been dying. Dali shat-tered that concept into a hundred pieces. He was saying to me, 'To hell with the rules! Paint what you like!'"

First oil painting 1967

With his newfound freedom, his enthusiasm returned, and he began to draw with renewed energy. From black and white drawings, he graduated to color pencils and began selling his drawings to classmates for twenty five cents each.

Shortly after that discovery, Jim's parents began to realize that he was actually serious about a career in art. They gave him a gift which helped him further advance his skill, a paint set. And with those oils, Jim did his first painting. Describing that, Jim says, "I took my old colored pencils, my new brushes and oils and, even, my fingers to make the painting into what I wanted. It was with that paint set that I really began to develop my own style of painting."

But another change in Jim's career was just around the corner. He admired Dali's technical bril-liance, his lighting, realism and colors. He sometimes even copied Dali's work. Jim says of this period, "One day, I realized that I couldn't be Dali, and that I really didn't want to be him. Dali brought out the artist in me, and I found out that I needed to be that artist. I needed to be just me, Jim Warren." Jim's painting improved, and by seventeen he was selling his pictures for five to ten dollars. His career as a professional artist was growing steadily now. His goals were a car, an

apartment and then retirement. Then he realized that these adult subjects were a long way off for him. He would wait until he was eighteen to worry about them.

Drugs had taken on southern California and won. Along with drugs, a new style of art called, "psychedelia" was moving across America. Jim saw it, liked it, and his art began to reflect it.

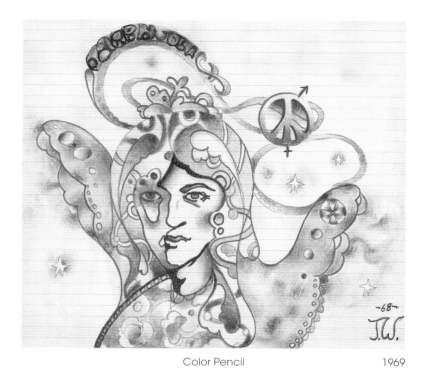

Color Pencil 1969

In the Fall of 1967, he was approached by Miss Gotto, the school art teacher, who informed Jim that he had failed his art class because he didn't, "...follow the assignments." He says about this, "I don't really know what she was so upset about. I had drawn a tree like everyone else in the class. It's just that in place of tree limbs, my tree had human arms. I guess I just shook her up with my own idea of what a *really* interesting tree might look like!"

Not a year later, Jim's already limited interest in school and his passionate interest in art led him to quit school. He wanted to experience life as an artist in the real world. During the next five years, Jim discovered that life was not the "Leave it to Beaver" world he had grown up in. Along with thousands of other American youth, he

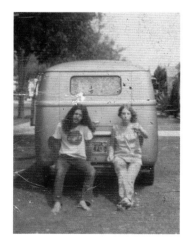

Jim with friend 1971

dropped out of mainstream, traditional America. He drove and lived out of the standard VW van.

And, he did, indeed, experience life of the sixties. Looking back on the drug era, he says, "Many of my rock idols, as well as some of my friends, had died of drug overdose, and I saw other friends close to me give up on their goals in life. But during all this chaos and distraction, I learned some things which made me stronger and helped me survive as an artist, the most important being my observations of the destructive nature of drugs. I found out that the only thing drugs do is make people forget that they have problems and shortcomings, all the while hiding behind a delusion of 'creativity.' I believe that there is an artist within each of us, and that drugs only thwart or destroy that priceless ability. I also found that if one wants to 'get away' from the stresses of life for a while, a simple walk or a day at the beach helps to achieve that better than any drug.

"I realized that I really had nothing to complain about. I had a wonderful family and a great childhood. I was blessed with the career of my choice, and I had a head full of ideas. I also realized that I was not getting any painting done. If I was going to be an artist, I had to work. I had to get up each day and paint. When I saw this, I started preaching to my friends, 'Hey, you guys! Let's get off our butts and get to work and be something!'" Jim was, by then, twenty years old. Jim's new approach to life brought about a surge in his art production. Fans were paying him from twenty to fifty dollars for each painting, and he was beginning to support himself. He continued living out of his van and used a friend's garage as his studio. By choice, he was a struggling artist, though he knew that if conditions got bad, he could drive the two blocks to his parents' house for a shower, food, and a peaceful night's sleep.

It was during one of these visits when some of Jim's paintings caught the eye of his father who looked at Jim's mother and said, "You know, I think he really can do something with this." Remembering that moment, Jim says, "That comment from my Dad encouraged me to work even harder to make my career happen."

During this period, he frequented art museums, gathering inspiration from Rembrandt, Monet, Magritte and Norman Rockwell. He knew that these great artists were teaching him and influencing his style. But his favorite place for inspiration was the beach. He loved the sun, sand, surf, and the people on the beach. Nature and people would become his favorite and most prominent subjects. He was entranced by the waves which, in

his eyes, had a life of their own. He envisioned wild horses rising up out of the foam of the crashing California waves. He studied children running and playing on the beach, surfers, and golden, suntanned girls lying motionless on the sand. He enjoyed the endless, empty space of the long California beaches. His technique was developing rapidly during this period as he avoided formulas, painted everything from the bizarre to the traditional, and continued to experiment.

In 1973, at twenty four, Jim took on a venture which combined many of the things he loved. He became a successful dance promoter, designing and drawing his own promotional ads. In this new adventure, he was involved with rock music, people and art. But in February of 1975, when a riot broke out at one of his enormously popular dances, he realized that being a rock promoter was just another distraction from his first love, painting. He went back to his canvas.

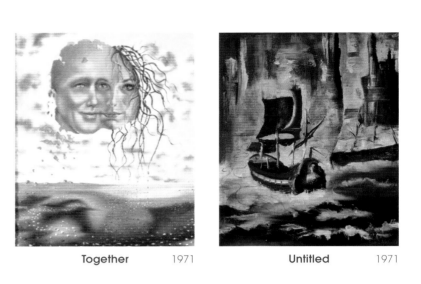

Together 1971 Untitled 1971

For seven months he devoted his time exclusively to painting, and he finished a large collection. About that time, Jim's friends and family encouraged him to enter the Westwood Art Show. This show was the second largest in the U.S., with the work of four hundred artists. Viewer attendance was usually at around one hundred thousand. Jim had never shown his work, and he, naturally, experienced all of the fears one would expect with this enormous exposure. However, he agreed to try. And in October of 1975, he found himself at Westwood, showing his paintings.

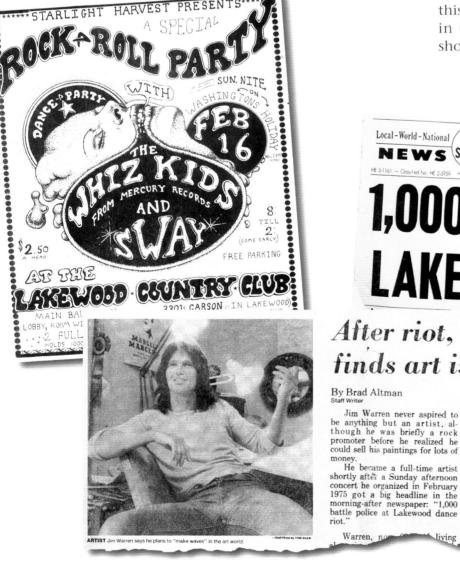

ARTIST Jim Warren says he plans to "make waves" in the art world.
—Staff Photo by TOM SHAW

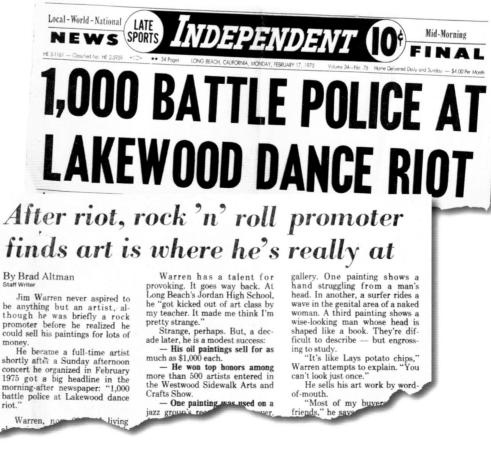

Local–World–National NEWS LATE SPORTS *INDEPENDENT* 10¢ Mid-Morning FINAL

HE 5-1161 — Classified No. HE 2-5959 ** 34 Pages LONG BEACH, CALIFORNIA, MONDAY, FEBRUARY 17, 1975 Volume 34—No. 76 Home Delivered Daily and Sunday — $4.00 Per Month

1,000 BATTLE POLICE AT LAKEWOOD DANCE RIOT

After riot, rock 'n' roll promoter finds art is where he's really at

By Brad Altman
Staff Writer

Jim Warren never aspired to be anything but an artist, although he was briefly a rock promoter before he realized he could sell his paintings for lots of money.

He became a full-time artist shortly after a Sunday afternoon concert he organized in February 1975 got a big headline in the morning-after newspaper: "1,000 battle police at Lakewood dance riot."

Warren, now __ __ living

Warren has a talent for provoking. It goes way back. At Long Beach's Jordan High School, he "got kicked out of art class by my teacher. It made me think I'm pretty strange."

Strange, perhaps. But, a decade later, he is a modest success:
— His oil paintings sell for as much as $1,000 each.
— He won top honors among more than 500 artists entered in the Westwood Sidewalk Arts and Crafts Show.
— One painting was used on a jazz group's re_____over.

gallery. One painting shows a hand struggling from a man's head. In another, a surfer rides a wave in the genital area of a naked woman. A third painting shows a wise-looking man whose head is shaped like a book. They're difficult to describe — but engrossing to study.

"It's like Lays potato chips," Warren attempts to explain. "You can't look just once."

He sells his art work by word-of-mouth.

"Most of my buyers ___ friends," he says

10

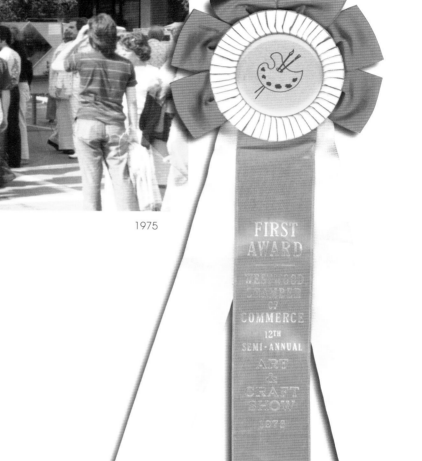

Westwood Art Show display 1975

Large crowds gathered to see the work of this "new" artist. Some lingered, studying his work for the full two day show. His paintings sold in three digit figures for the first time, and he felt rich beyond his wildest dreams. But, the most significant occurrence was that he won first place. And in that accomplishment, he achieved all he had set out to do. That young, aspiring magician was indeed creating magic with his oils and canvas. His love of entertaining was fulfilled, with crowds of art lovers at Westwood. But, most of all, he had wanted to paint on his own terms, from his own creative mind's eye, not what was "popular" in the art world. He had worked hard to get there, and he had arrived, dreams intact. A successful end to youthful search, and a prophetic beginning to what would become, over the next twenty years, the immensely successful career of a brilliant American artist.

This has been the story of Jim's beginning. In the following chapters, he will tell you about how his art has evolved since that remarkable day at Westwood. He'll show you dozens of his works in each of the forms he has mastered, and he will share the wisdom of his experience with others building their own careers in the field of art.

So, now let's hear from Jim Warren, himself. And, as he is so fond of saying, "Hope you enjoy the show!"

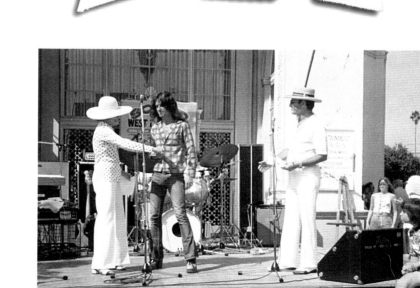
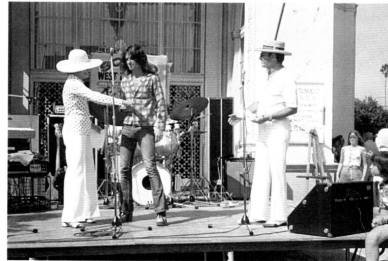

Accepting First Place Award 1975

11

Jim's Early Works 1967–1976

In 1975, I gathered up all of my early drawings and sketches. Those I didn't sell or give away were packed up in a taped box. It wasn't until doing research for this book, twenty years later, that I dug up these old pictures from my youth.

Looking through them was an adventure and when I got to the last of them, I realized I had experienced the rare opportunity of reviewing my own history as a fine artist. Aside from the memories which sprang up as I looked at these images, I also found it interesting to see how my style and technical ability had developed as I went on to paint professionally.

These works, which I used to call my "old stuff," have now earned a special place in my life. I hope you enjoy viewing these as much as I enjoyed digging them up and dusting them off for you.

Crayon drawing – 5 years old 1954

Jim's one and only sculpture 1969

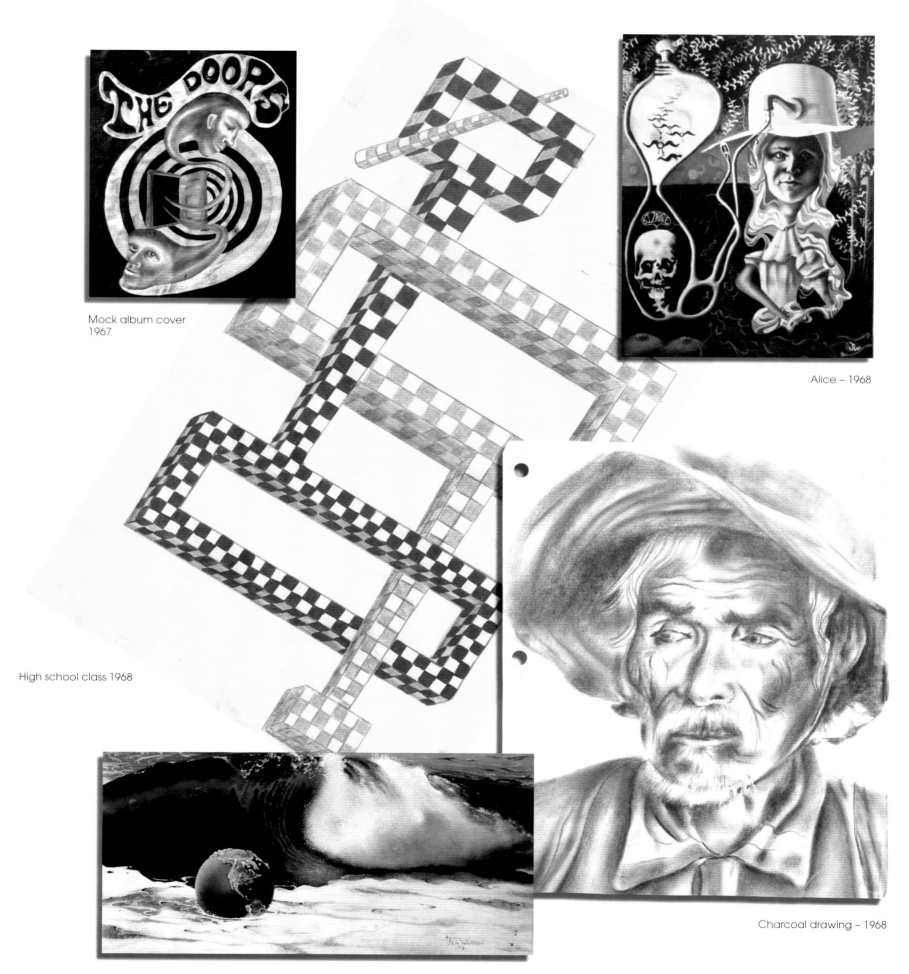

Mock album cover
1967

Alice – 1968

High school class 1968

Charcoal drawing – 1968

Oil painting – 1968

Donovan 1969

Future 1969

Christmas card for Jim's grandma 1970

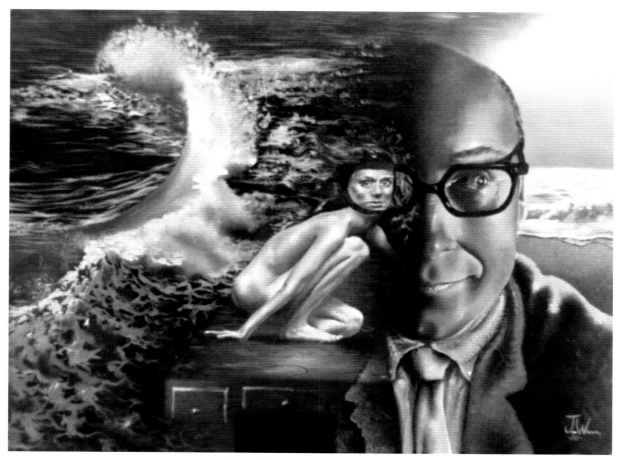

Executive's Dream by the Sea 1972

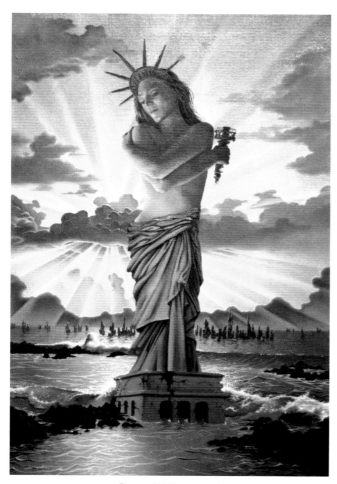

Raped & Ravaged 1972

Pencil drawing 1976

15

JIM WARREN

Although I consider myself self-taught, I took several classes in 1975, studying life drawing and portrait drawing, where I had the opportunity to sketch live models. This helped me loosen up my sketching techniques, which are crucial to the beginning of each of my paintings.

17

Pencil sketch of live model

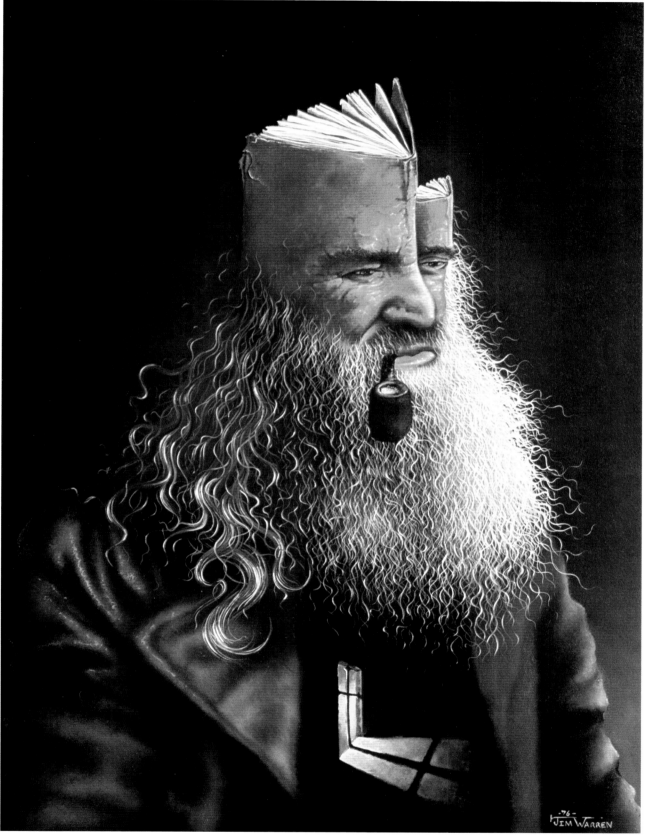

The Wise Man 1975

This painting was inspired by a 1975 visit to the L.A. Museum of Fine Art where I first viewed the works of Rembrandt and the other old masters. The next day, I decided to "squeeze" in one more painting for an art show which was three days away. No time to plan or think it out, I quickly sketched an idea on paper. Then, I went to work on the painting depicting my subject's head as a book of knowledge and his heart an empty room. I called it "Wise man." It wasn't until it was finished that I realized how much an influence that trip to the museum had had on me.

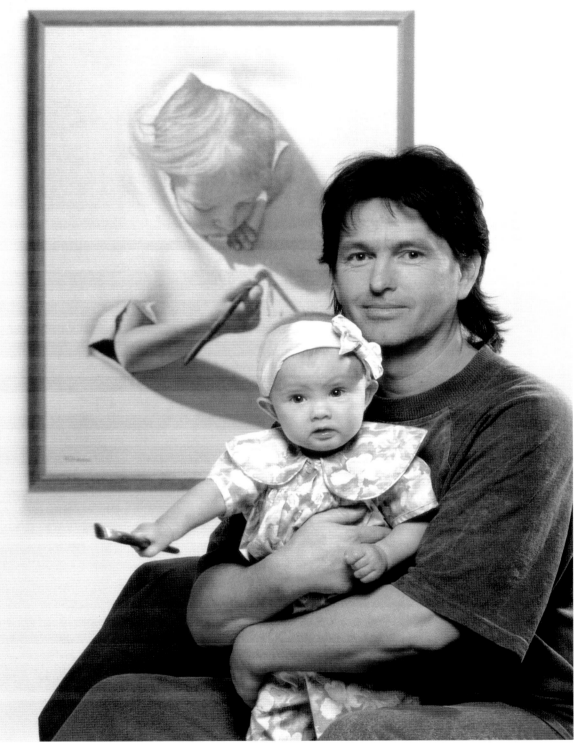

L.E. prints available Jim & Drew with **Awkward Age** 1992

Fine Art (featuring Surrealism, Fantasy, and Environmental)

My first experience in the fine art world was in 1970. My work at that time was more crude and surrealistic than the work I produce today. I was nineteen at the time and had sold paintings to friends and acquaintances. Bursting with confidence, I felt I was ready to show my paintings in an art gallery.

I lived thirty miles from what was one of the largest art communities in the country, Laguna Beach, California. I put together a portfolio of paintings and photographs, got in my car and headed down Pacific Coast Highway to make myself known.

I passed a gallery that looked interesting to me, parked my car and walked in. Laying my portfolio down on the table, I said to the gallery owner, "I'd like to show my art here." The lady was nice and looked at my work. She didn't say that my art was bad, but that it was, "...the wrong kind of art." Giving me her best advice, she said, "If you want to sell paintings, do clowns and nudes. That's what sells." Baffled by what I had heard, as I left I thought, "Clowns? Nudes? How about something a little more imaginative, like, say, nude clowns?" My visits to a few other galleries ended with similar results. "If you want to make a living as an artist," went the script, "you need to paint (something else,) because we don't sell surrealism."

I was experiencing my first major career decision. Do I compromise and paint subjects contrary to my own artistic purposes, or do I starve? Well, youthful arrogance won the toss. But to my surprise, I didn't starve. In fact, the only times I really did badly were when I tried to paint what was considered "saleable" subject matter. My heart wasn't in it, and my work suffered. And when I painted what interested me, regardless of how "unpopular" the subject, I made money. There were certain subjects I wanted to paint and a certain style in which I wanted to paint them. That, I knew, was why I had chosen to pursue a

"Clowns? Nudes? How about something a little more imaginative like, say, nude clowns?"

career as an artist. Anyone can paint a tree or a dolphin or a child, but if an artist doesn't love and understand those subjects, the joy of painting erodes into a dry, boring exercise in technical skill, with the artist's heart and soul left in the dust of artistic "popularity." There are hundreds of art forms in the world, almost as many as there are artists to paint them. And no end to subjects in which to specialize, including clowns. But it only works if the artist, himself, loves and wants to paint clowns.

Despite discouragement from these galleries, I showed my work for years at outdoor art shows, and this gave me the freedom to experiment and grow. Years later, instead of my searching for galleries, the galleries searched for, and found, me.

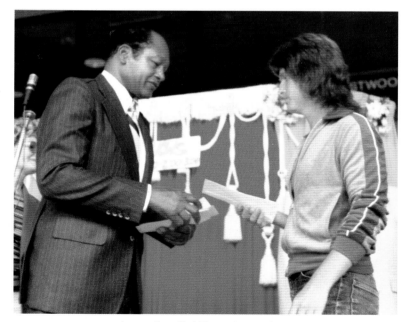

Accepting First Place Award from
Los Angeles Mayor, Tom Bradley 1979

Surrealism

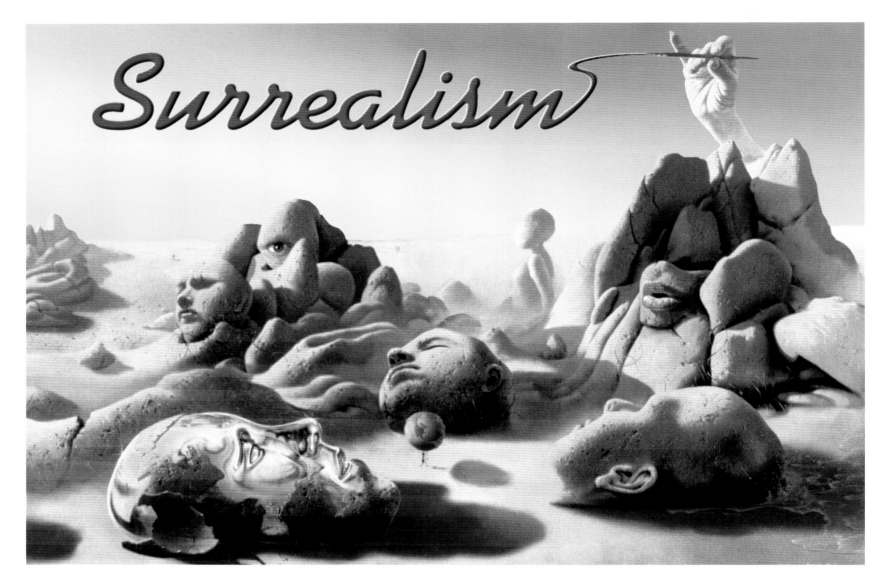

Surrealism is defined as, "Unusual and unexpected arrangements and distortions of images." Further, the form is described as a modern art movement which tries to show what takes place in dreams and the subconscious.

I have my own definition for surrealism: fun. I say this because that was all I was doing when I began painting surrealistic images. On my canvas were worlds I could create, change or distort at will, with no limitations. There were seldom any hidden meanings in my paintings, though people often spent hours trying to analyze their deeper meanings. They would then call me up in a frenzy of excitement to tell me that they had figured it out, and to let me know the hidden meaning of my painting. Not to ruin their fun, I acknowledged them politely. But I did realize that everyone sees something different in each of my paintings, something that relates specifically to them. And that, to me, is what art is all about.

Whether there is or isn't a hidden meaning behind any of my surrealistic paintings, what I often was doing with that form was to express how I felt about things I had experienced or observed in life around me.

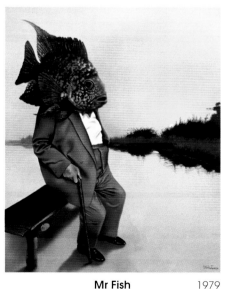

Mr Fish 1979

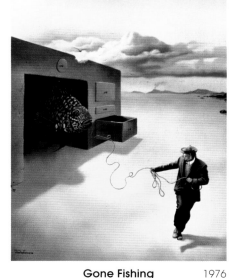

Gone Fishing 1976

22

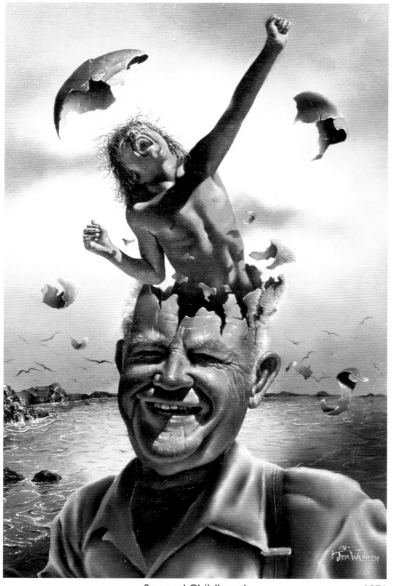

Second Childhood 1976

question, which keeps us thinking and smiling to ourselves even to this day. I'd like to think that my paintings leave the viewer with some lingering sense of mystique. However that mystery is answered, I know it will be different for each person.

So these days, when an art lover asks about or suggests to me the hidden meaning behind my surrealistic works, I tell him, "It means whatever you want it to mean."

Sharing my surreal paintings with others and having them contribute their visions to my work is a part of my job which I really enjoy. Here are some of my paintings in this genre. Have fun with them!

"Second Childhood" was such an example of this. While living in California, I was often at the beach. I noticed an elderly man who came each day to that same spot, and he and I made it a habit to talk for awhile. He would tell me the latest jokes and then run off to the surf for his daily swim. He was eighty years old and retired. I recall looking at him one day and thinking, "He's really revisiting his childhood." Based on this idea, he agreed to let me photograph him there on the beach, and from those photos, I did a portrait of him showing the top of his head exploding into pieces like an eggshell. From the inside, a child is breaking free from the confinements of his head. People usually understand the meaning of this painting without further explanation.

I've always admired the wonderful old black and white movies which left us with our imaginations on overdrive. The extraordinary screen-writers and directors of those days gave us the gift of the unanswered

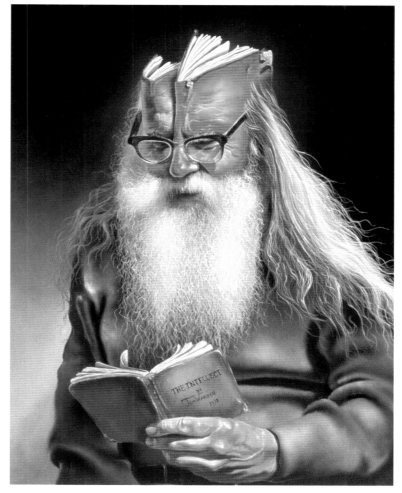

The Intellect 1978

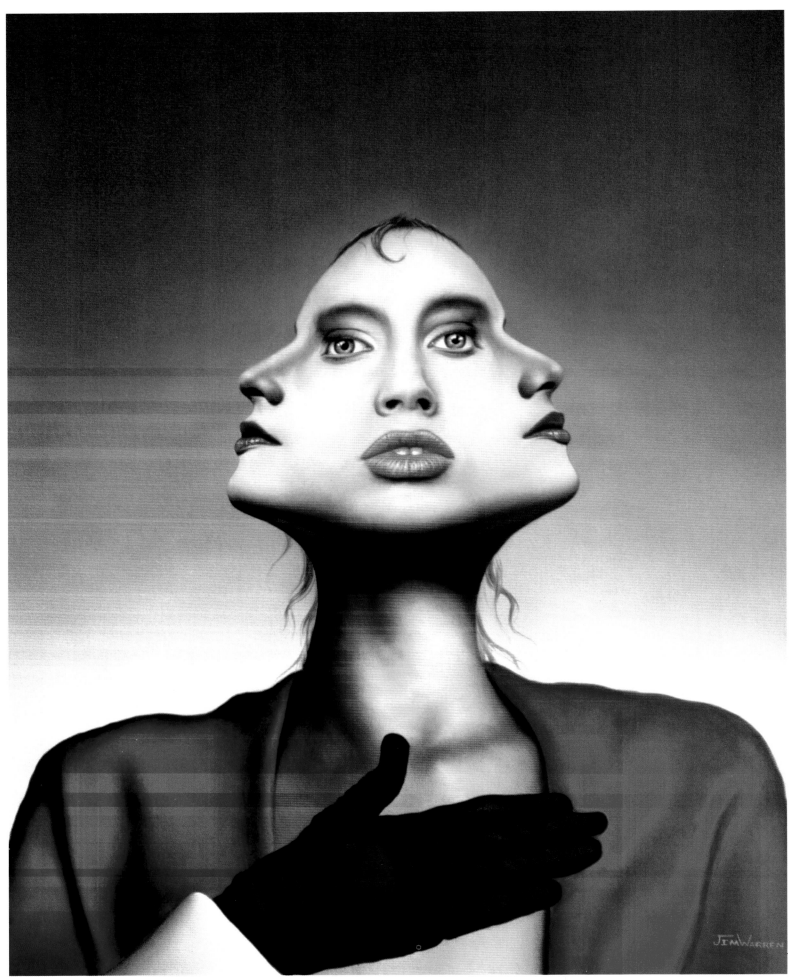

Welcome to America 1985

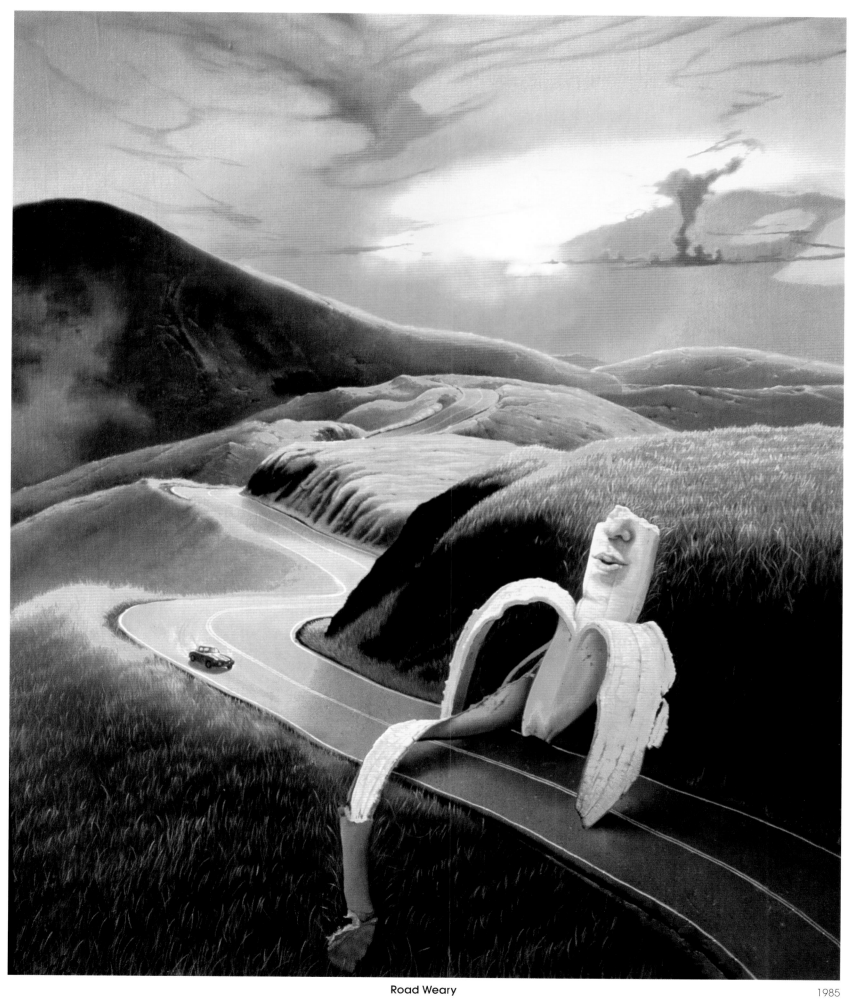

Road Weary

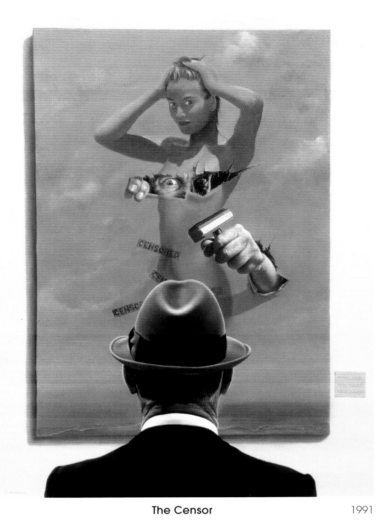

The Censor 1991

Jim with fellow surrealist and early influence, John Pitre, Hawaii 1994

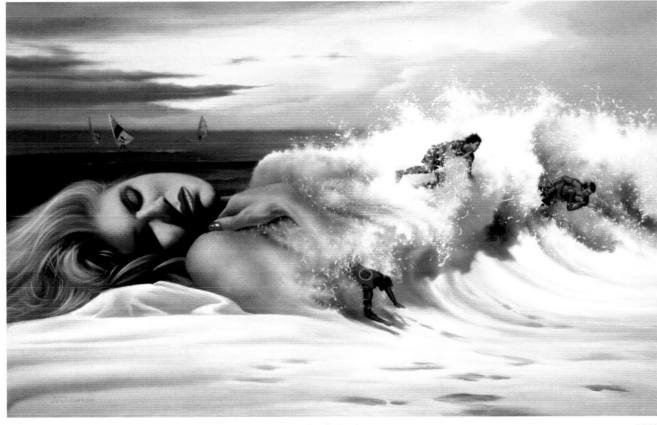

Body Surf 1989

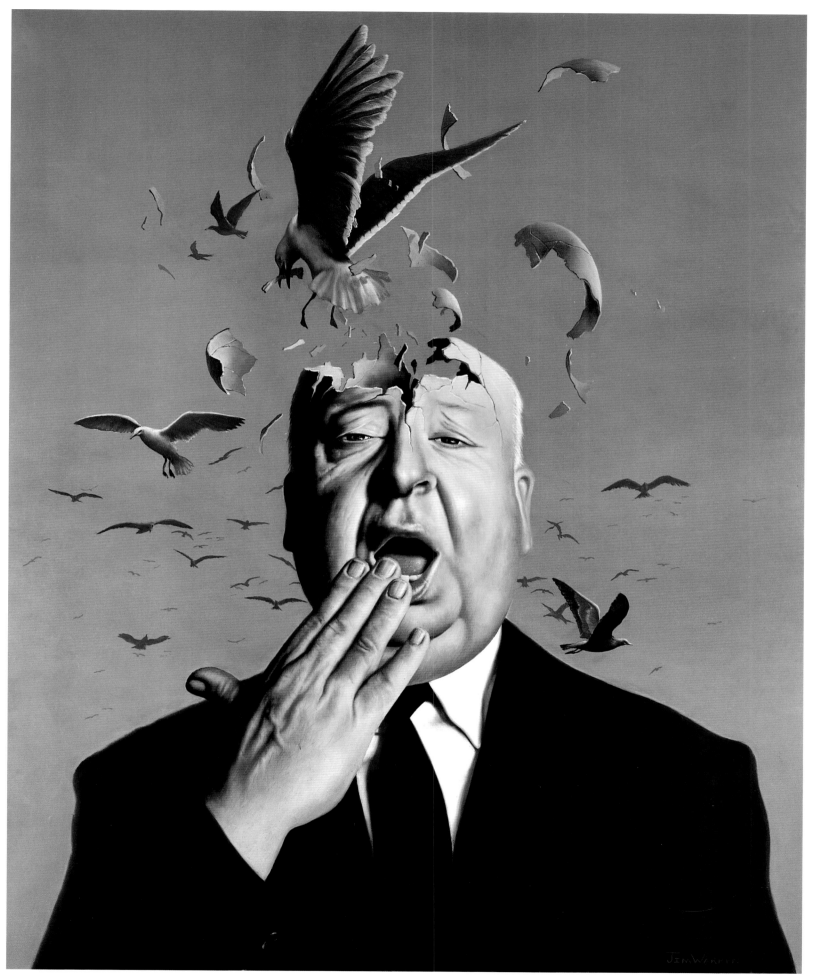

Birds

The Twilight Zone (oil and crayon) 1984

The Misfit (oil and crayon) 1985

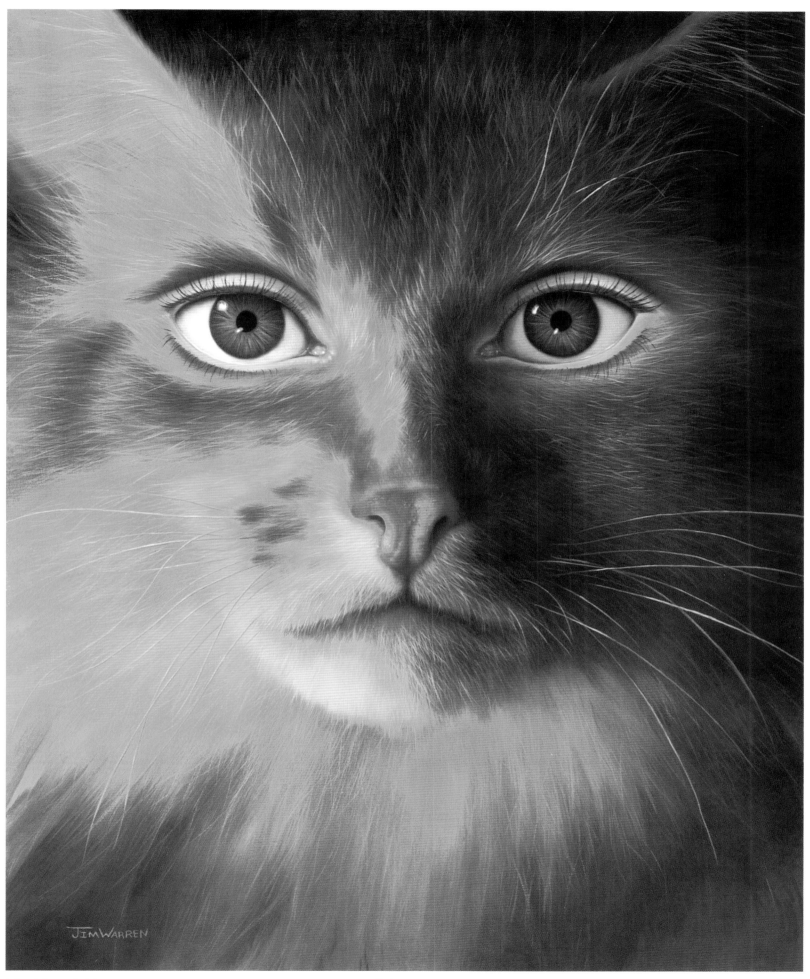

Catwoman 1989

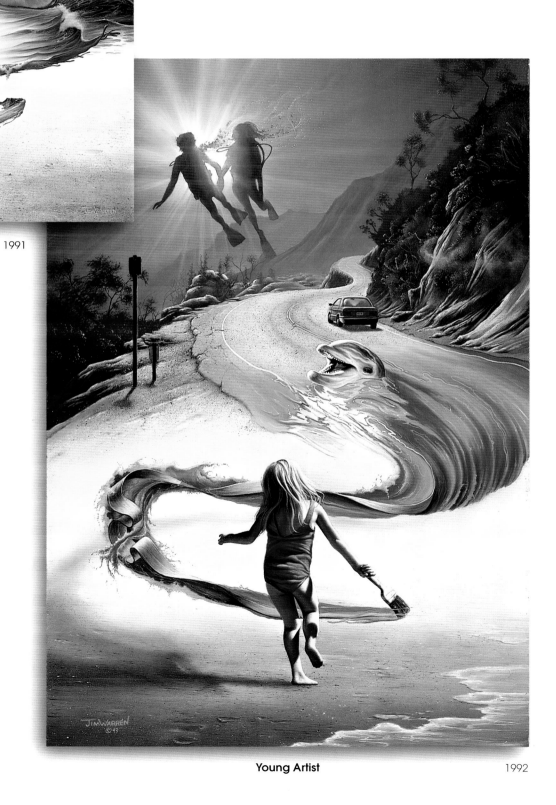

"I've always loved to paint
children doing what they do best:
using their imaginations."

Jim Warren

Child's Play 1991

Young Artist 1992

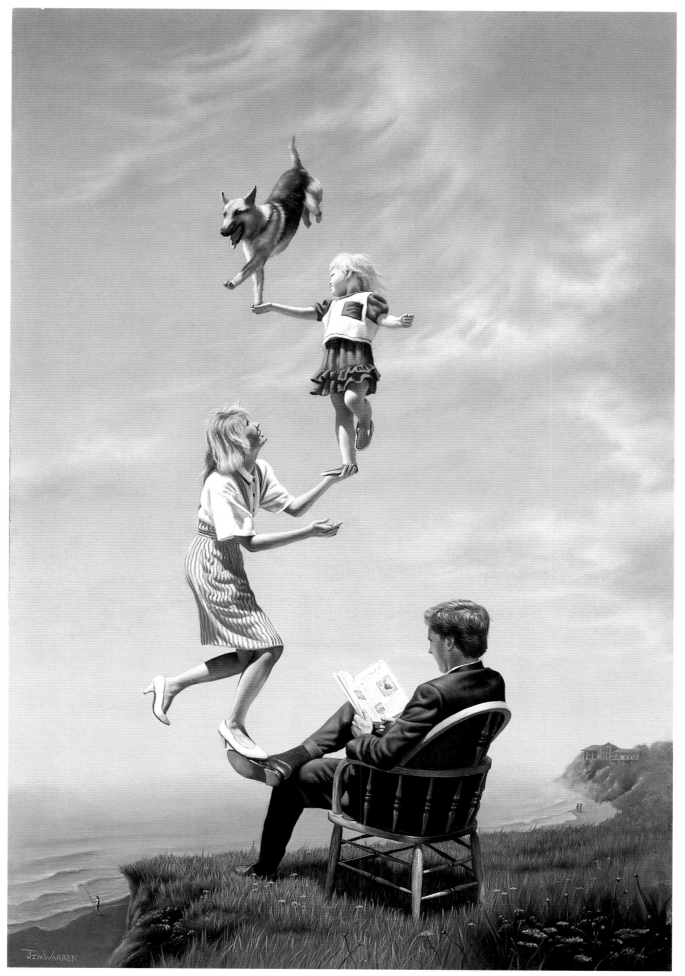

Family Balance

1990

31

L.E. prints available

Blue Eyes

1993

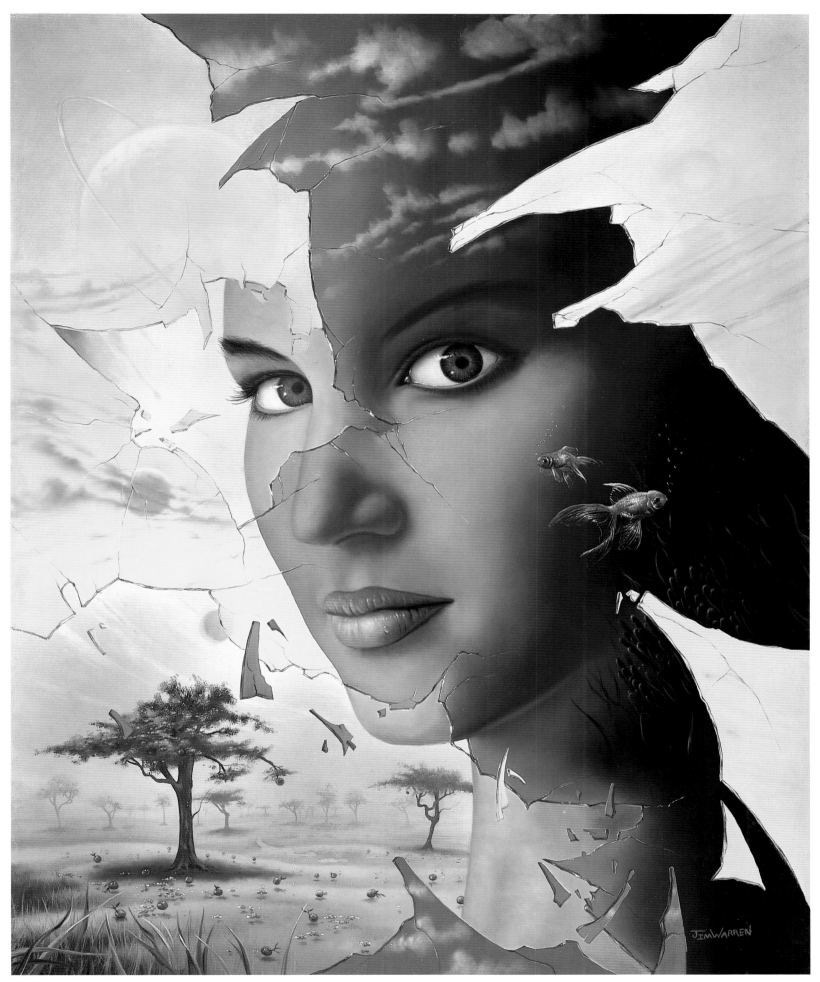

L.E. prints available **Wonders of Nature** 1990

33

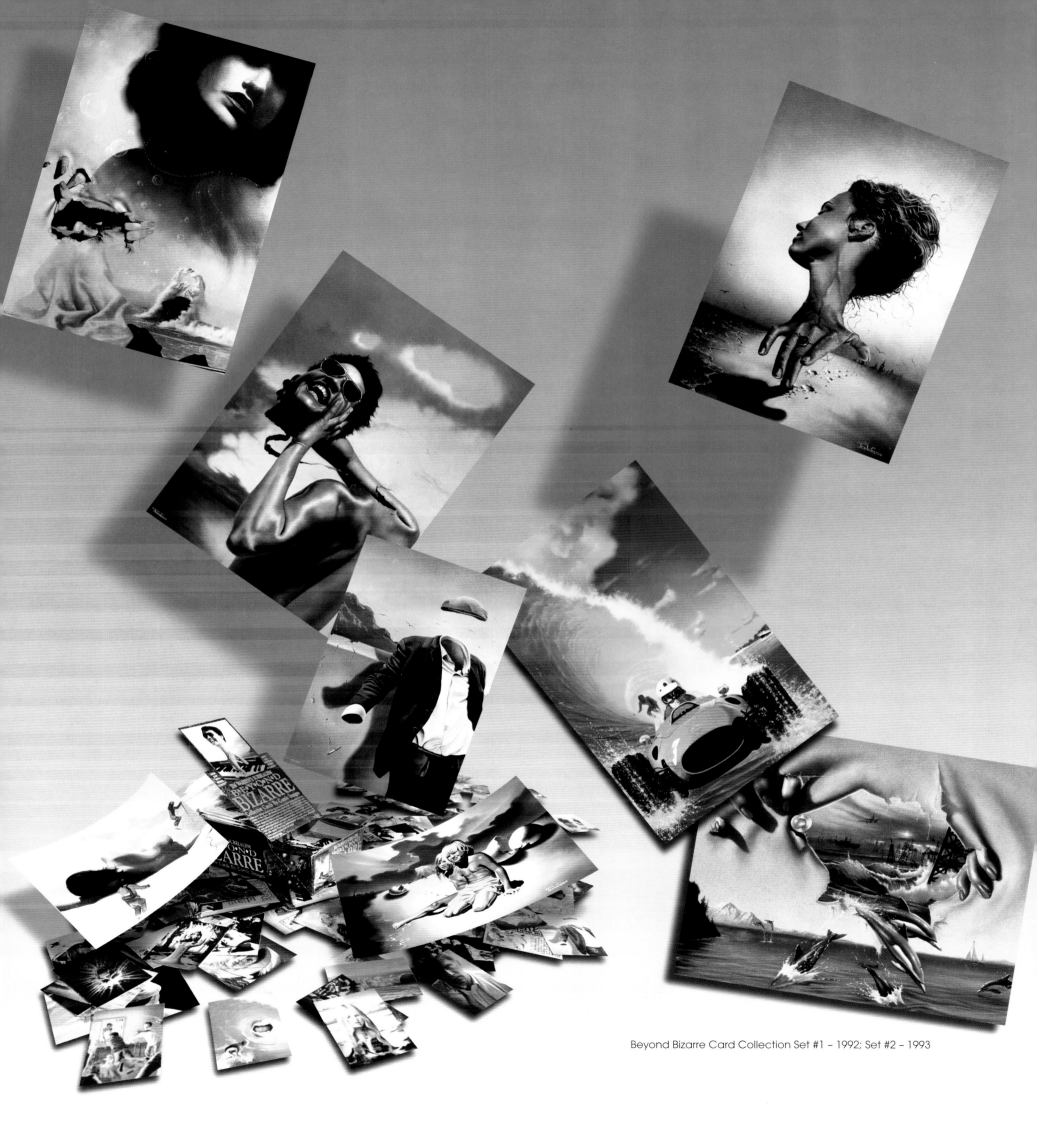

Beyond Bizarre Card Collection Set #1 – 1992; Set #2 – 1993

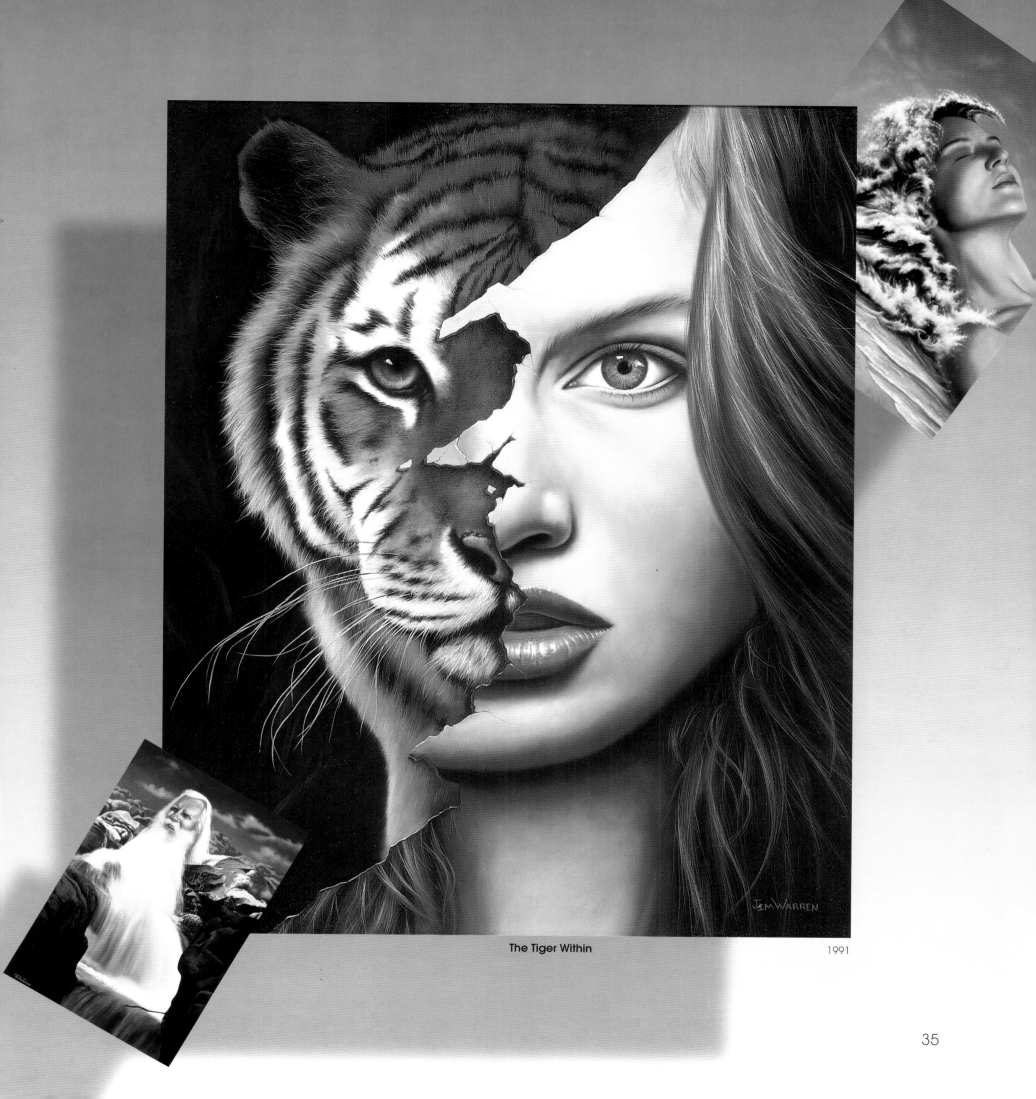

The Tiger Within 1991

35

Fantasy

I knew early in my career that I was a fine artist. Most of my work in those years was surrealistic though I never really considered myself a surrealist. Later my work started moving away from surrealism and more toward fantasy. The change was subtle, and I never really examined this shift in genres or what "type" of artist I was. I just kept painting. But I noticed that people often asked me the difference between the two forms. And oddly enough when I asked myself this question one day, I found that I, myself, was not clear on the answer.

Castle in the Sky – 1996

We all have fantasies, some wilder than others.

With a little research, I resolved the question. I opened my dictionary and found that the definition of fantasy was simply, "Product of the imagination." Under "surrealism," it said, "Unusual and unexpected arrangements and distortions of images."

Sometimes there is a fine line between fantasy and surrealism, and as my style changed from surrealism to fantasy, I had been unaware that I was crossing that line. I had never been comfortable being categorized as surrealist, fantasist, or otherwise. Dealing with both forms over the years brought me a freedom I enjoyed and continue to enjoy to this day.

We all have fantasies, some wilder than others. Most of us have things we'd like to do, characters we dream of being, and places we'd like to go, which may not exist in the "real" world. With a little technical skill, I was able to take the products of my imagination and put them down on canvas for others to see.

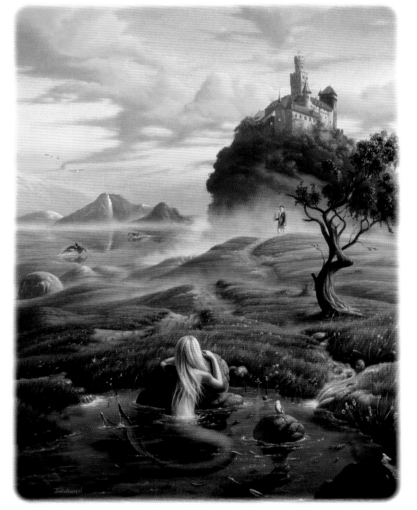

L.E. prints available **The Prince and the Mermaid** 1996

36

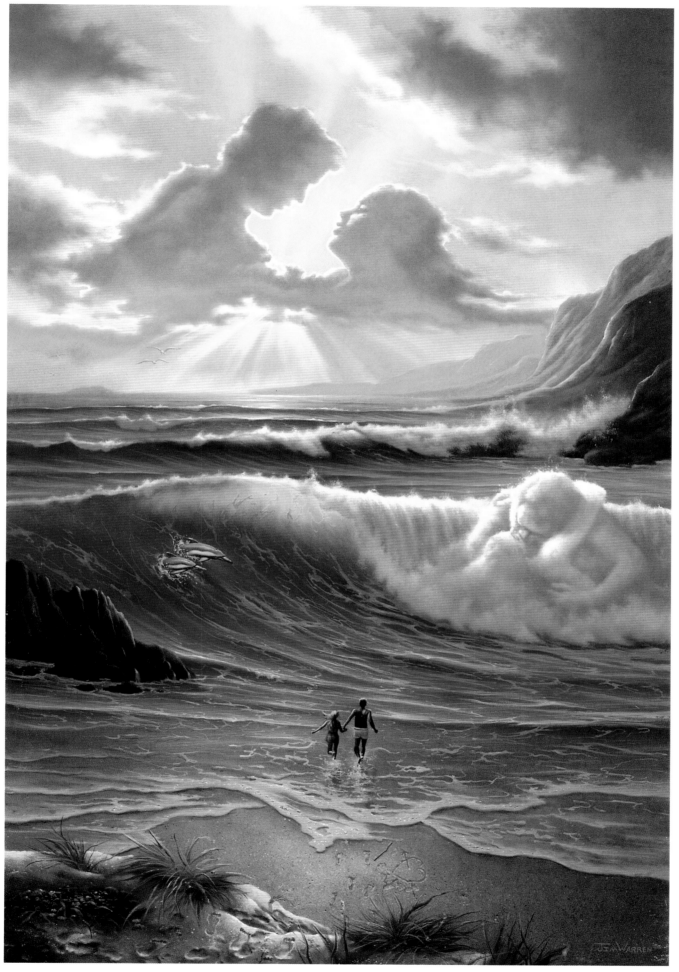

Romantic Day

1992

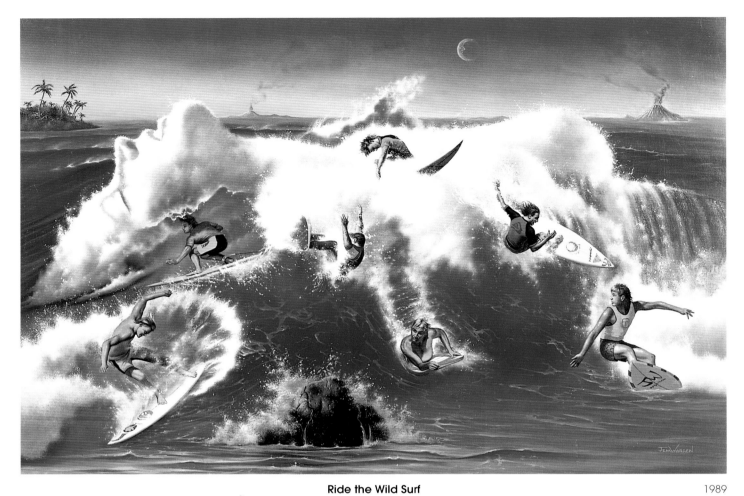

Ride the Wild Surf 1989

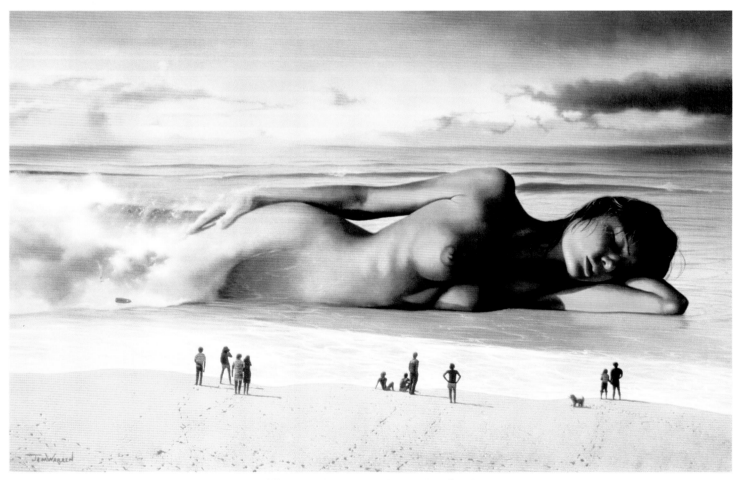

Mirage (originally entitled "Wipe Out") 1984

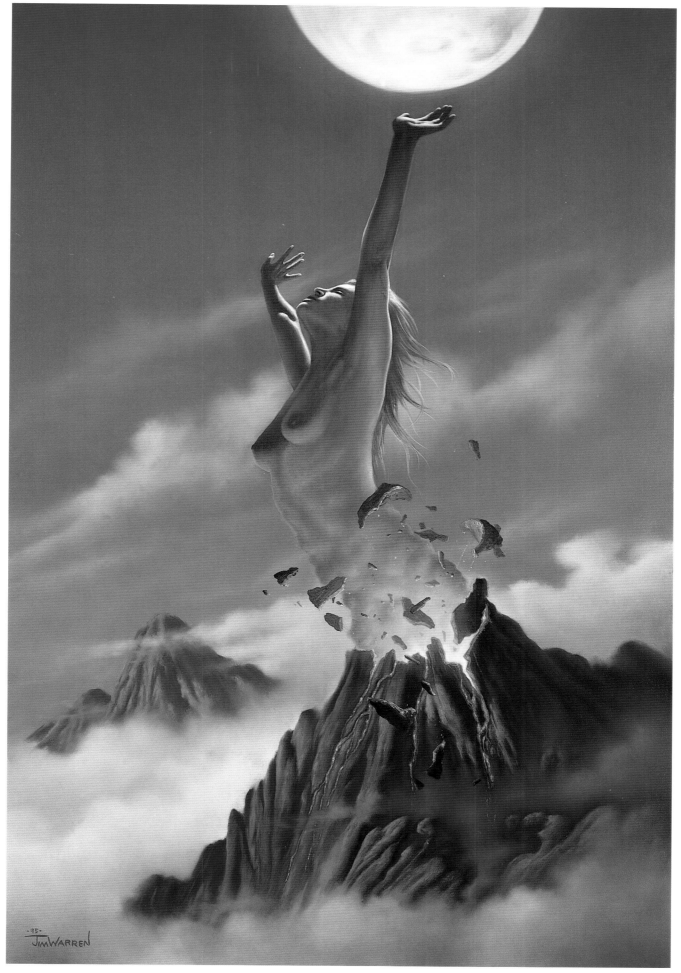

L.E. prints available **Pele Rising** 1994

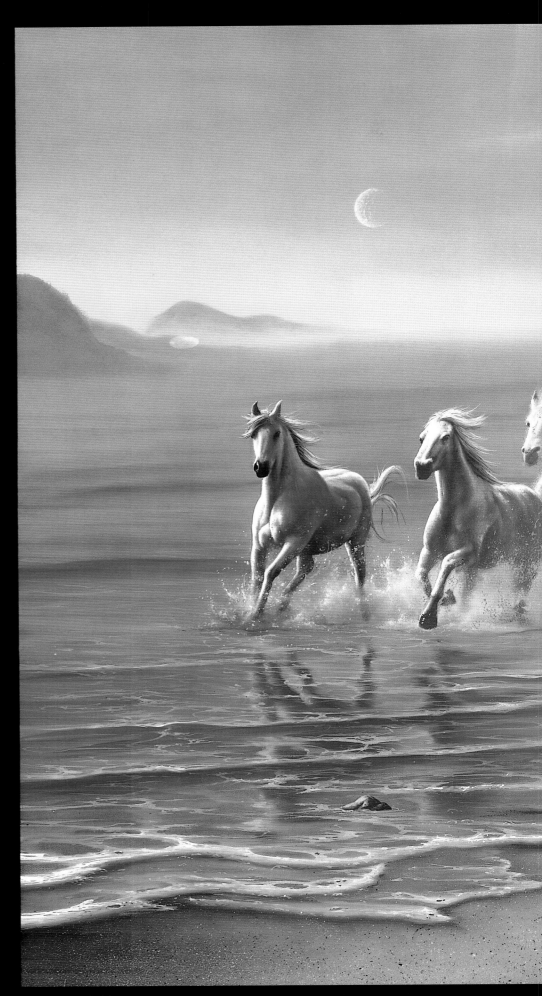

"I find Jim's art to be highly original and inspired."

John Travolta

L.E. prints available

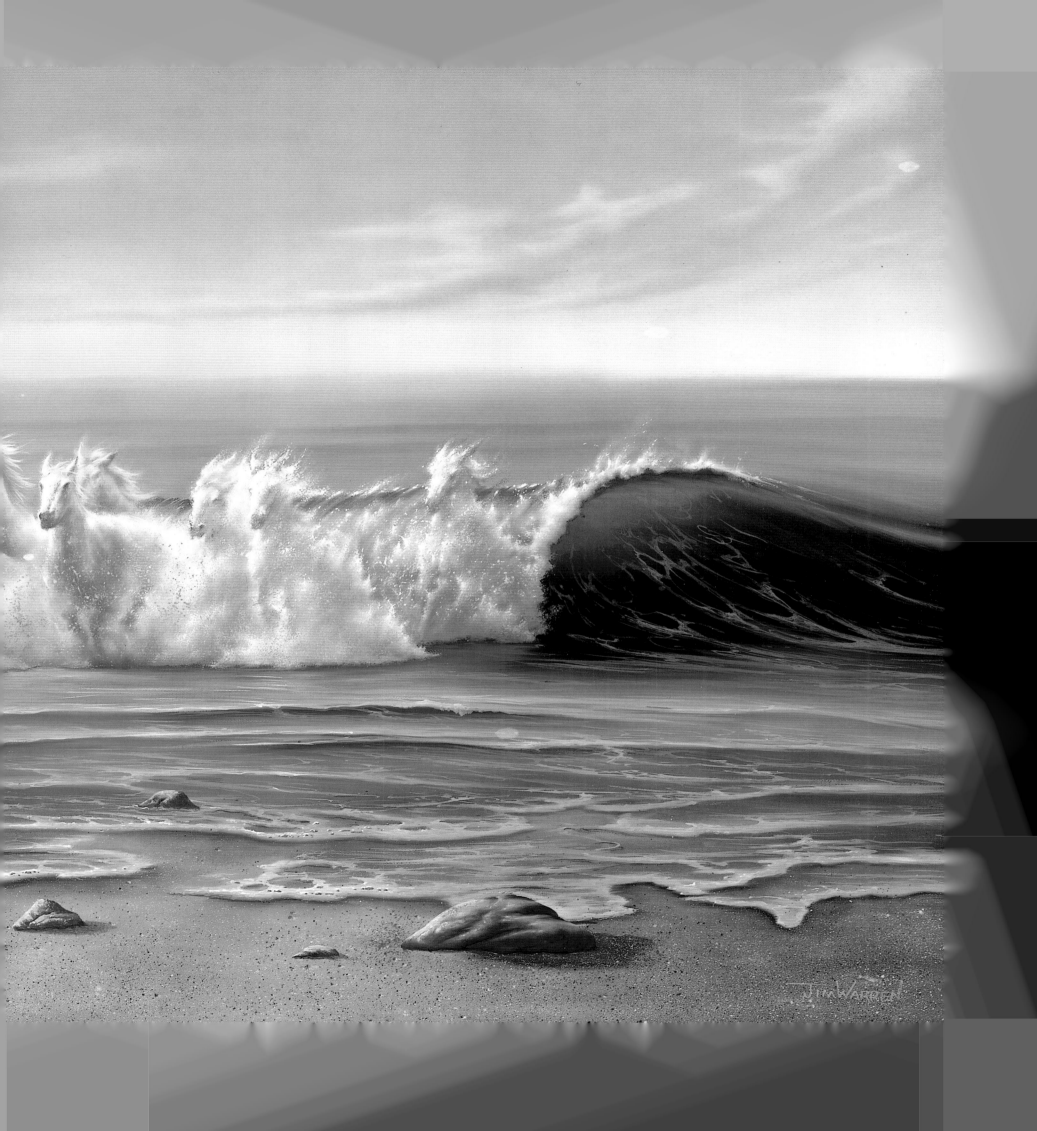

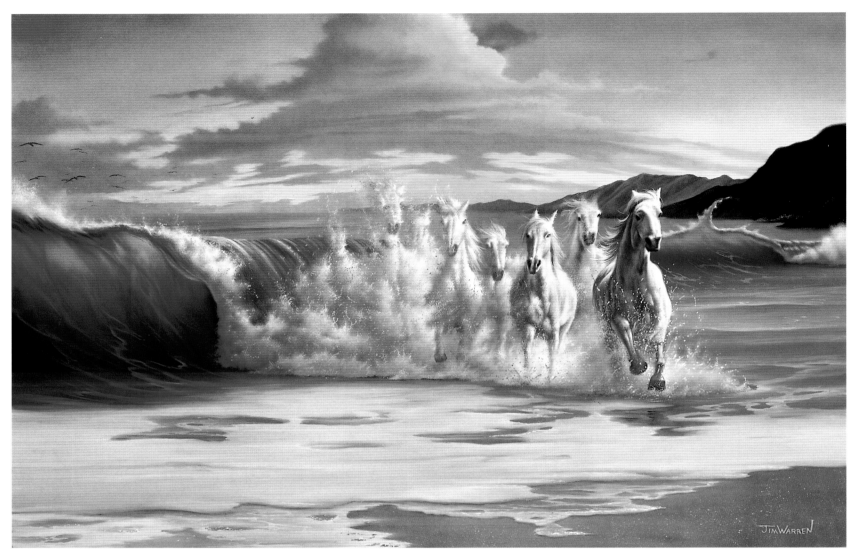

L.E. prints available **The Wave** 1993

Jim & Drew in Maui, 1993

Jim's parents, Don & Betty Warren, in Maui, 1993

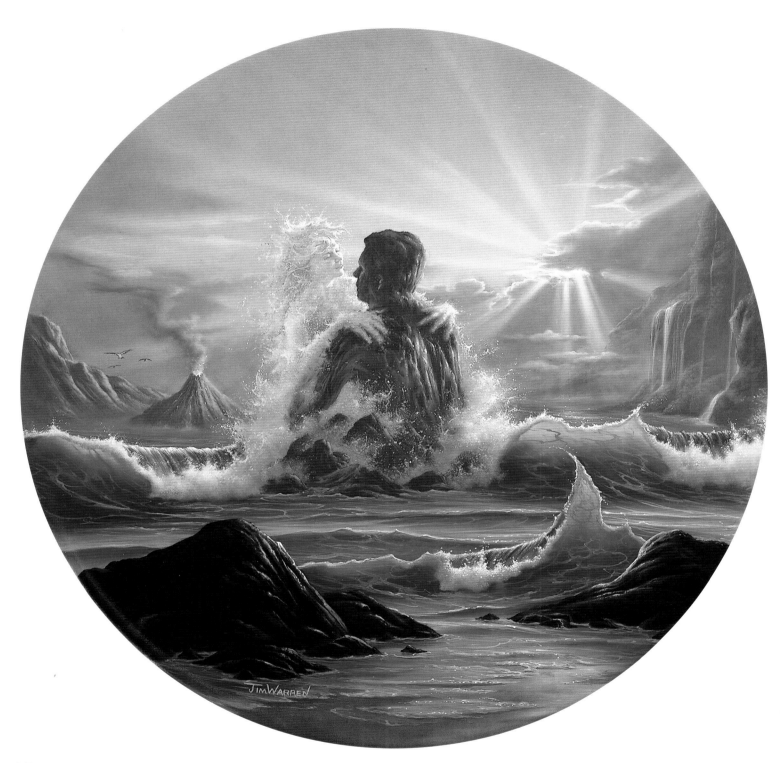

L.E. prints available **Nature's Embrace** 1995

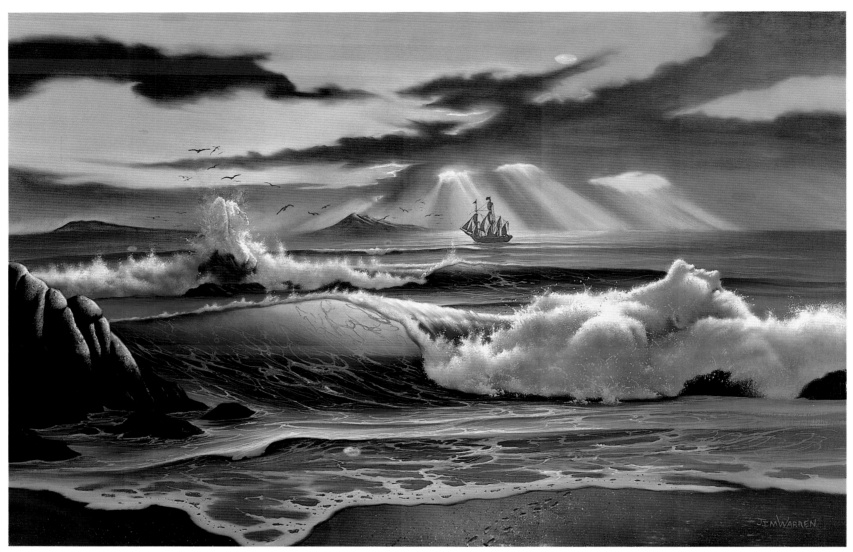

L.E. prints available **Fanta-Sea** 1993

Jim with brother Rick

Jim with friends and associates: Walfrido, artist;
Ron, gallery owner; Melissa, sales consultant

44

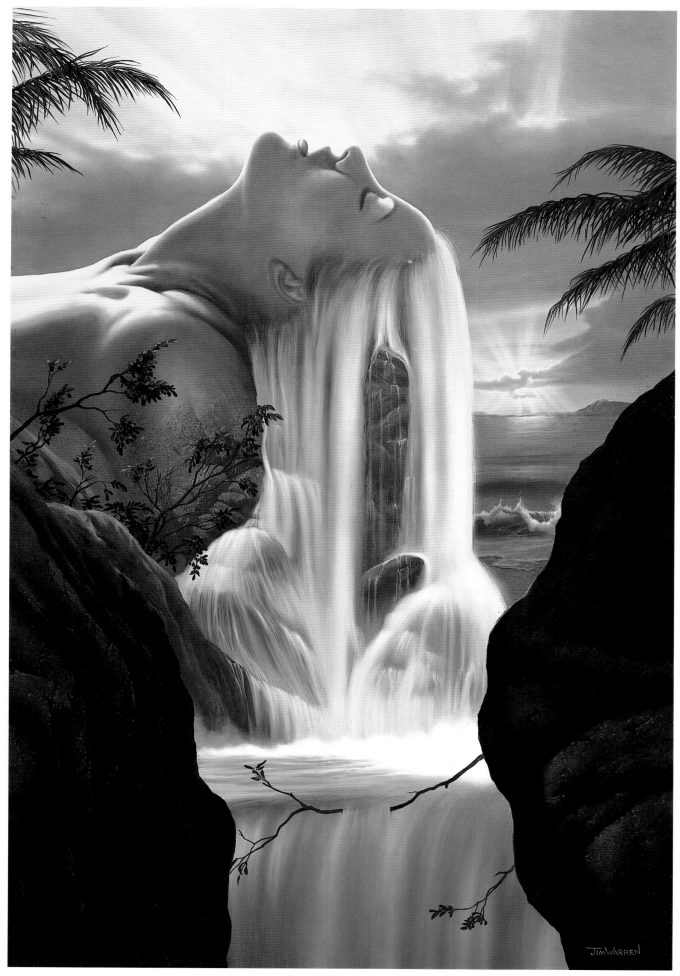

L.E. prints available **Island Dream** 1994

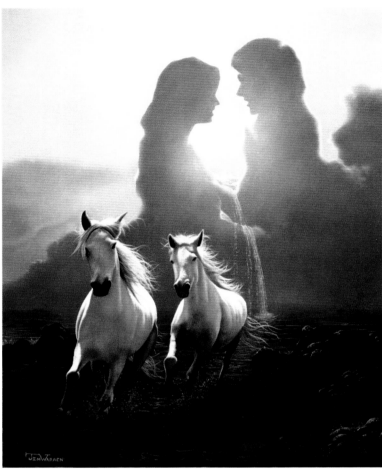

Together Again 1982

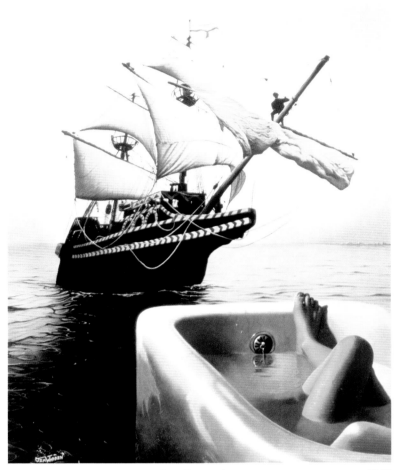

Day Dreaming 1982

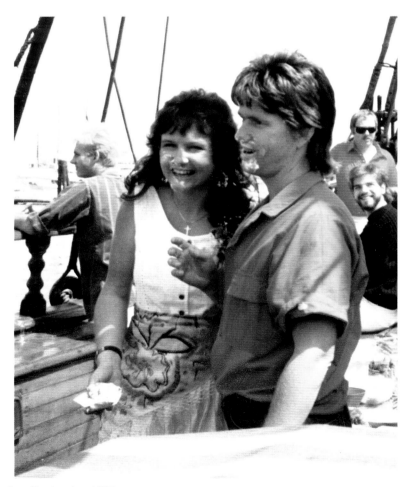

Jim & Cindy's wedding reception, September, 1987

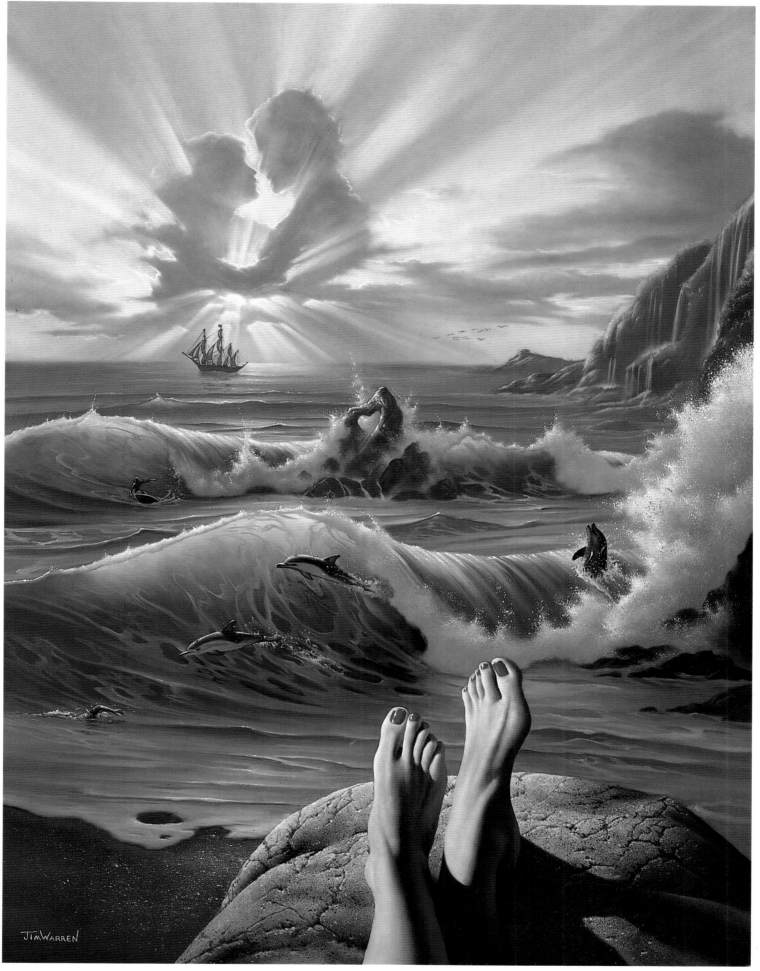

L.E. prints available **On a Clear Day** 1992

47

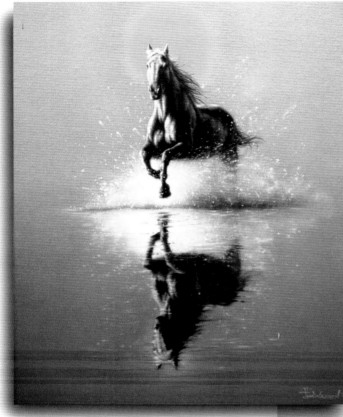

Run with the Wind 1996

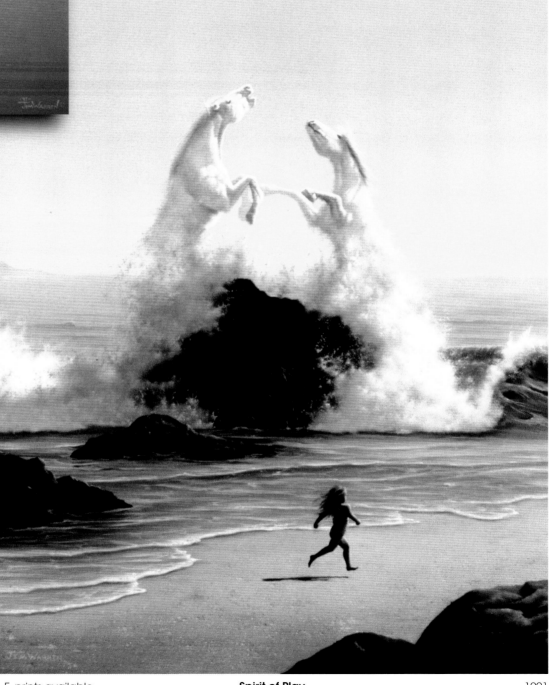

Spirit of Play 1991

48

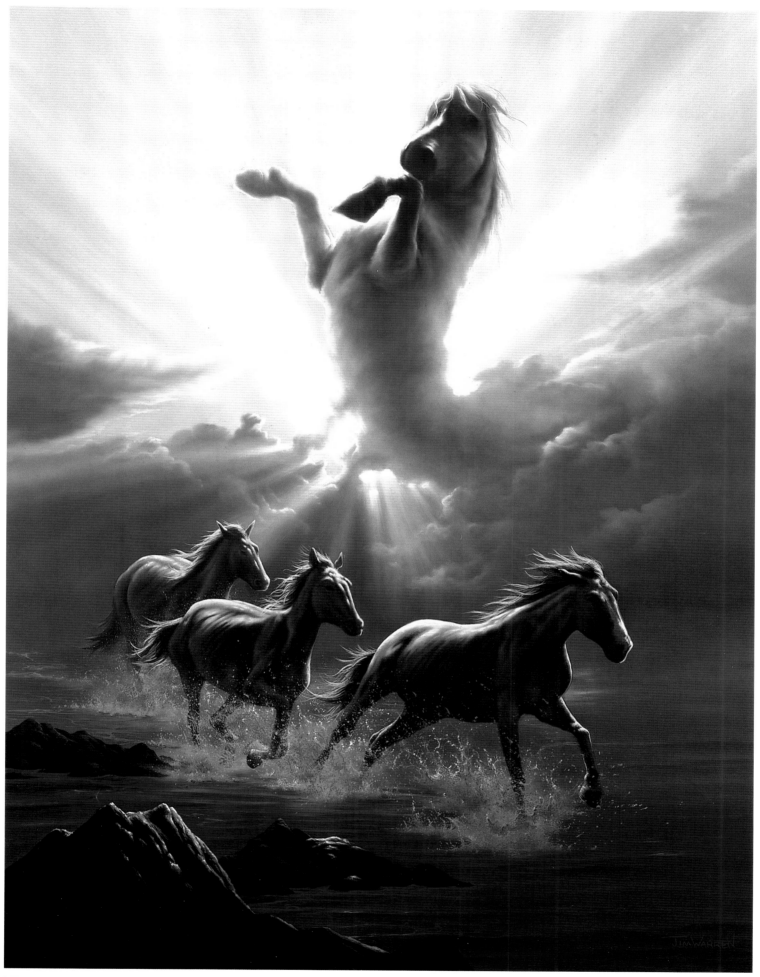

Wild Spirit

1994

49

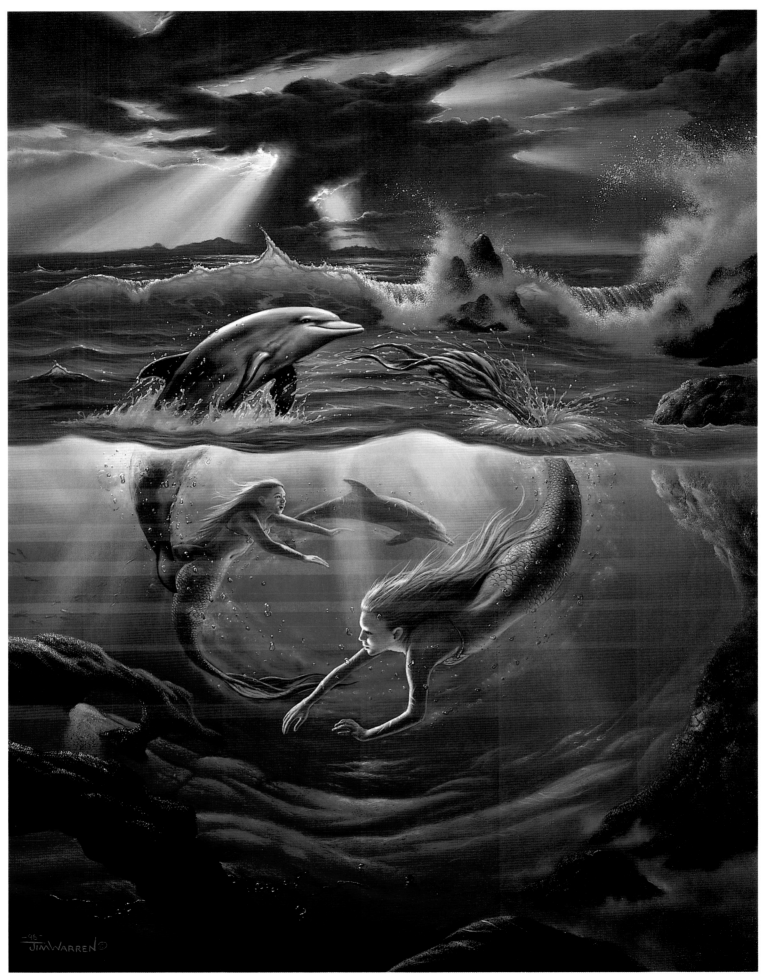

Circle of Friends

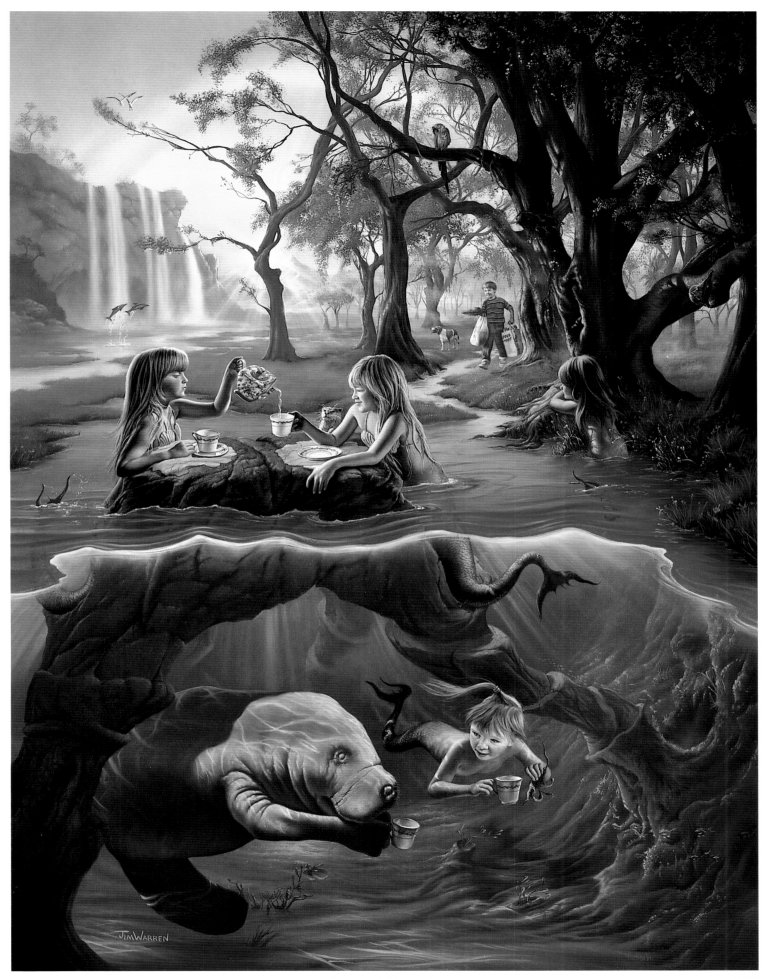

L.E. prints available

Mermaids' Teaparty

1995

Environmental Art

I became aware of environmental issues during my late teens. Dirty air, landfills and oil spills were subjects of nation-wide concern and protest. But the popular concept was that the dangerous conditions we had created on Mother Earth were not our responsibility. We thought of ourselves as victims of the real sources of the problem: the politician, the oil executive and other invisible powers. All the while, we were cruising in our gas guzzlers, filling our trash with aluminum cans and putting holes in the ozone layer. I, myself, didn't even know why the grocery store clerk asked me whether I wanted "paper or plastic" when I went shopping.

When I painted "Earth—Love It or Lose It" in 1989, I wanted to express how I felt about the life and beauty on this planet and the importance of preserving it for our children. For years I had wondered if a painting could actually change conditions in the world, whether one little picture could raise public awareness enough to get us actually doing something about it. Putting this image out in the public eye was the real test.

The public responded with a resounding, "Yes!" "Earth—Love It or Lose It" became the visual representation of the environmental movement and was seen around the world on tee shirts, posters, magazine covers and even billboards towering over the highways of America. Because I was the creator of this image, I was invited to numerous ecology expo's and was surprised at the huge number of ecologically beneficial products that were available. I saw everything from low energy light bulbs to solar energy for the whole house. There were non-aerosol spray bottles, ecologically safe laundry detergents, and even electric cars. Some of these products were not necessarily convenient or even practical yet, but they made me realize that an average guy like me *can* take responsibility for the state of the environment. Since painting "Earth—Love It or Lose It," I've noticed that even my own awareness of ecological issues has risen. For example, I find myself buying earth-safe laundry detergent and feel a little guilty when, out of laziness, I throw aluminum cans into the trash instead of recycling them.

Over the years, I have painted subjects that were shocking, and even depressing, concerning the ecological state of the earth. More recently, I've concentrated on paintings which simply communicate the beauty of nature, which can sometimes be the best environmental statement of all.

"Earth—Love It or Lose It," by the way, was originally entitled, "Uh-oh!"

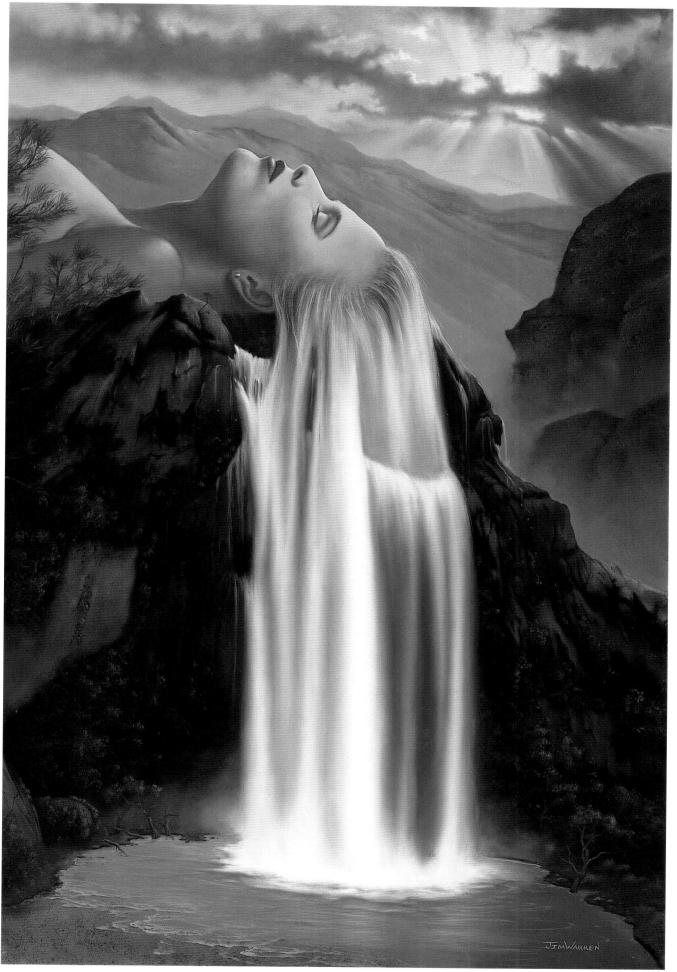

L.E. prints available **Natural Beauty** 1991

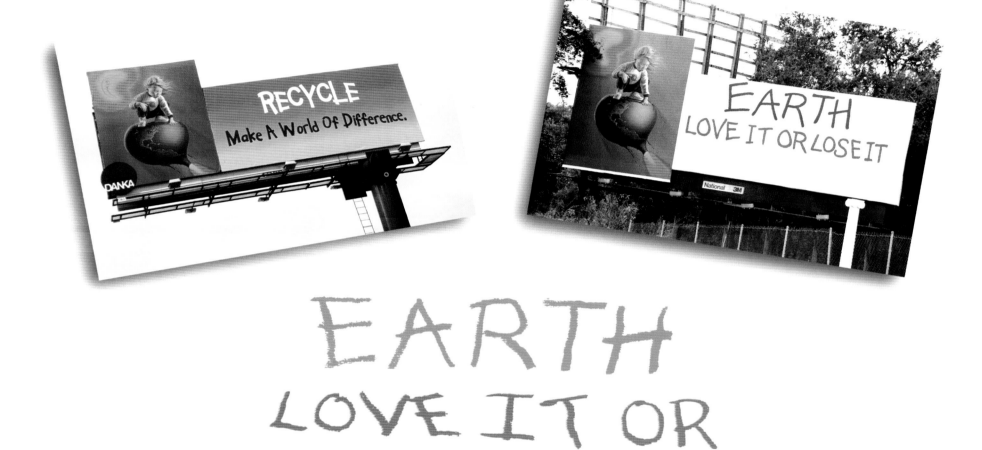

EARTH
LOVE IT OR
LOSE IT

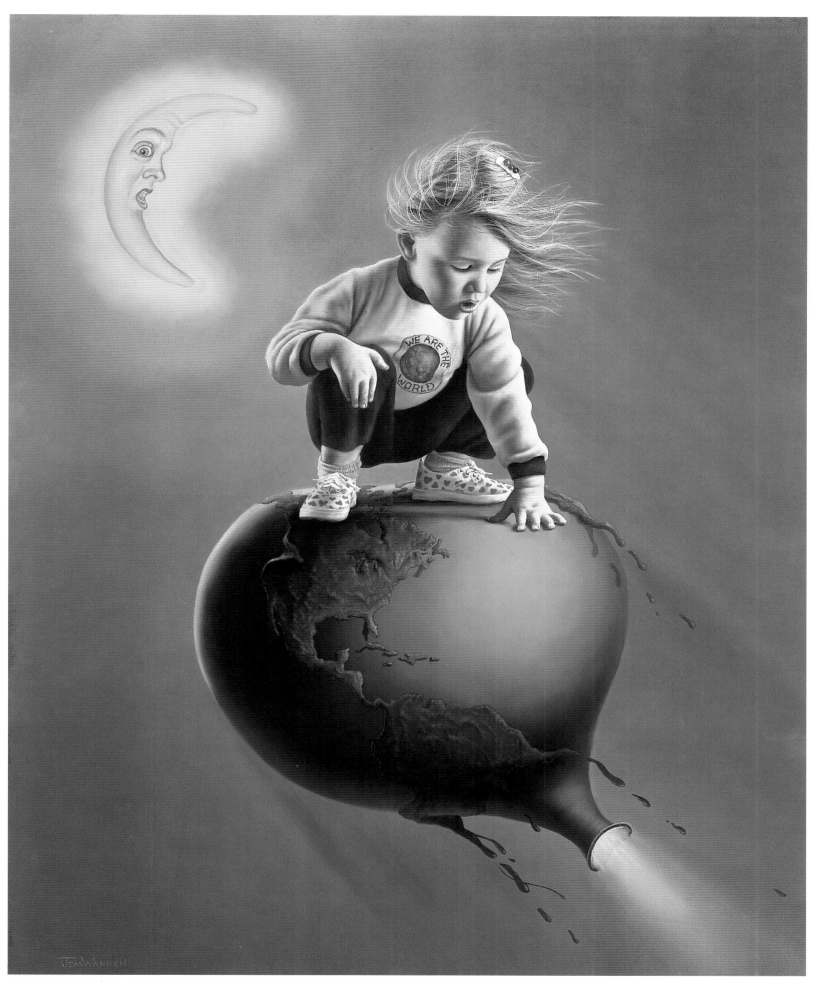

Earth—Love It or Lose It

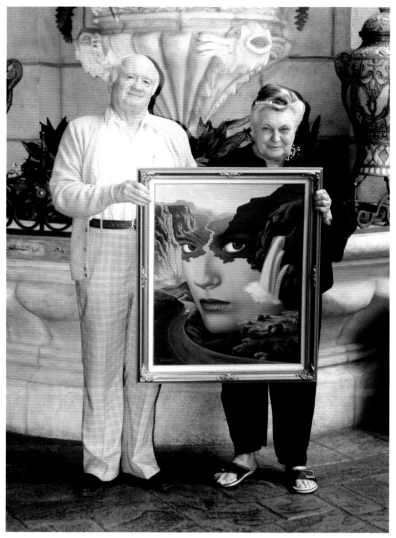

The owners, Frank and Eunice Madia

"We first saw a picture of the painting 'Mother Nature' on the March 1990 cover of a local magazine. In it was an article on Jim Warren which aroused our interest. So when he had a showing in Las Vegas, we went to meet him and see his work.

"We were greatly impressed by his imagination, technical excellence, and the beauty shown in his paintings. To our good fortune, 'Mother Nature' was at that showing, and we bought it on the spot. We have since bought several other pieces of Jim's work which we display with great pride and satisfaction.

"We shall always cherish his work!"

Frank and Eunice Madia
Las Vegas, Nevada

Original sketch for "Mother Nature"

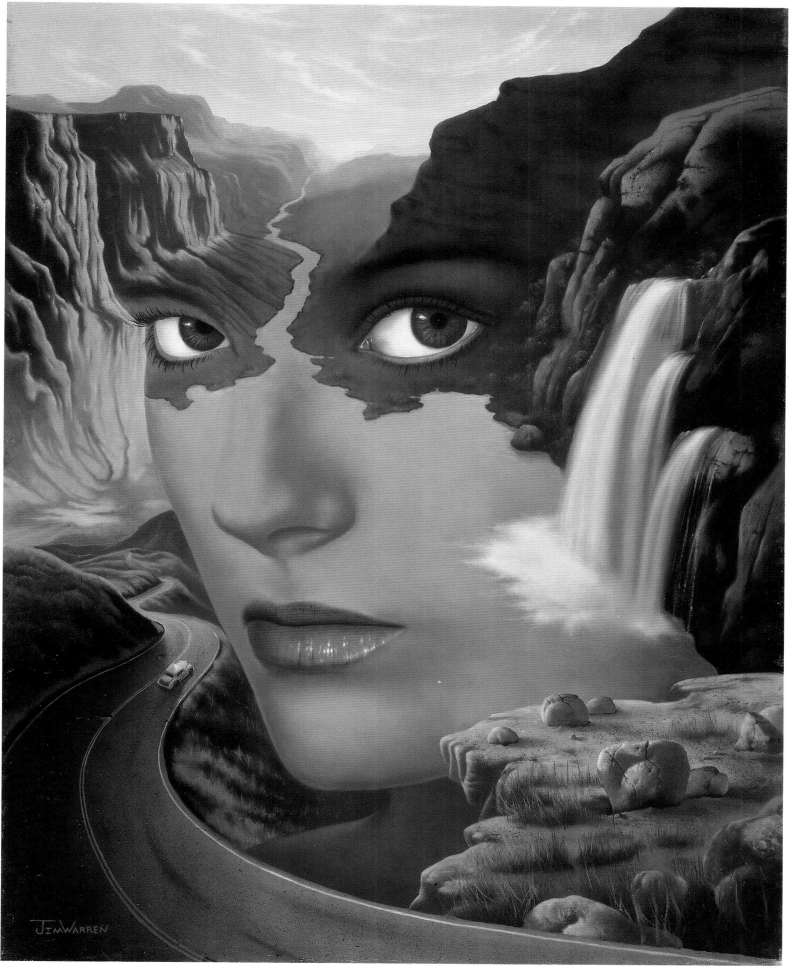

Pat & Evi Morita with jim

"Many of life's treasures come as a result of another's contribution to one's life. One of those life's treasures comes to our home as a result of the work of our friend, Mr. Jim Warren. It's as if God be-gifted us.

"Warmest alohas always, Jim."

Pat & Evi Morita

Pat Morita played in "Happy Days" and starred in the "Karate Kid" series.

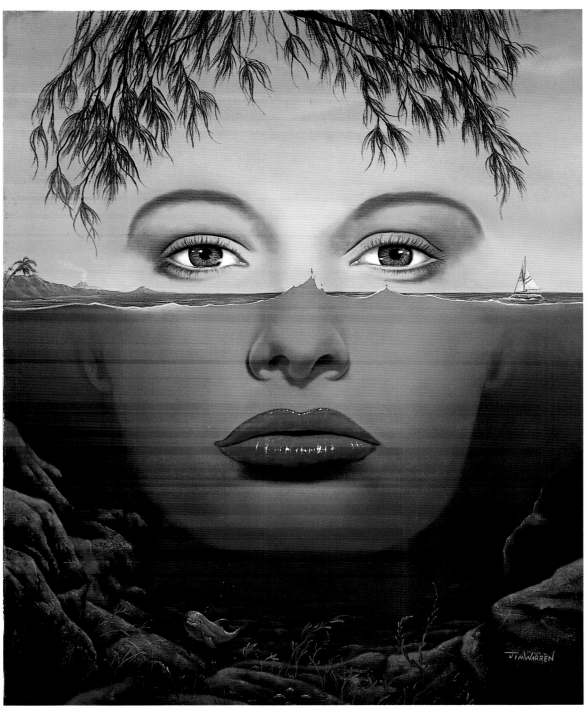

L.E. prints available **Island Girl** 1990

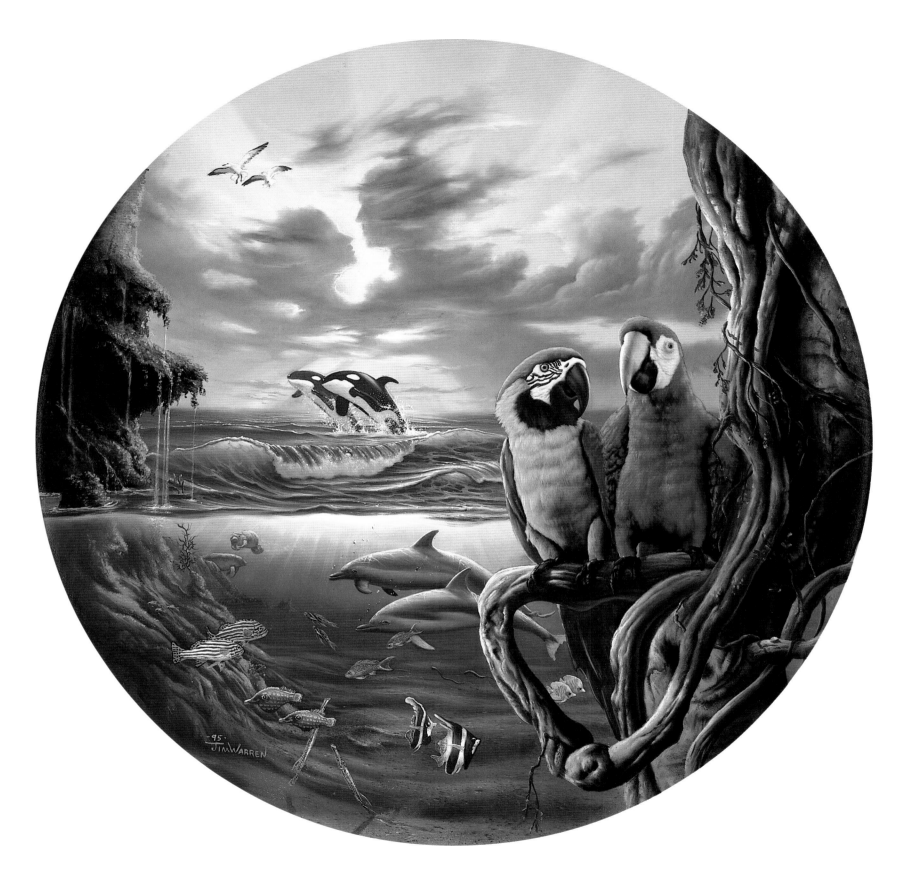

L.E. prints available **Paradise** 1995

59

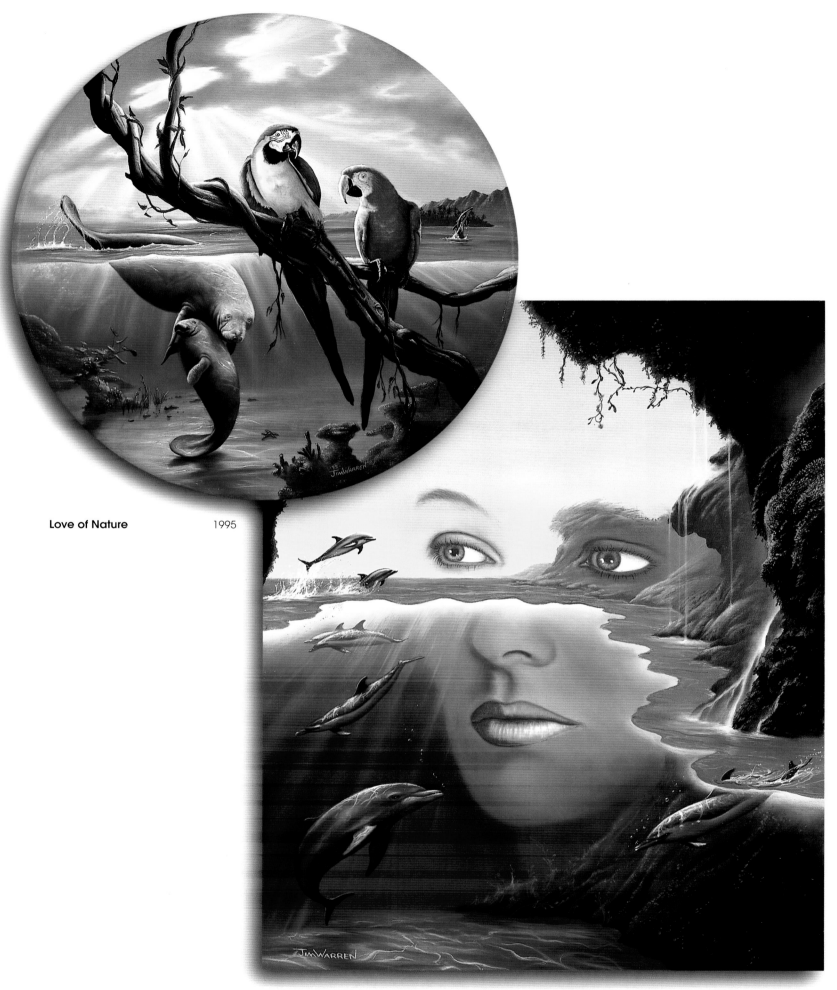

Love of Nature 1995

L.E. prints available **Friends of Mother Nature** 1995

60

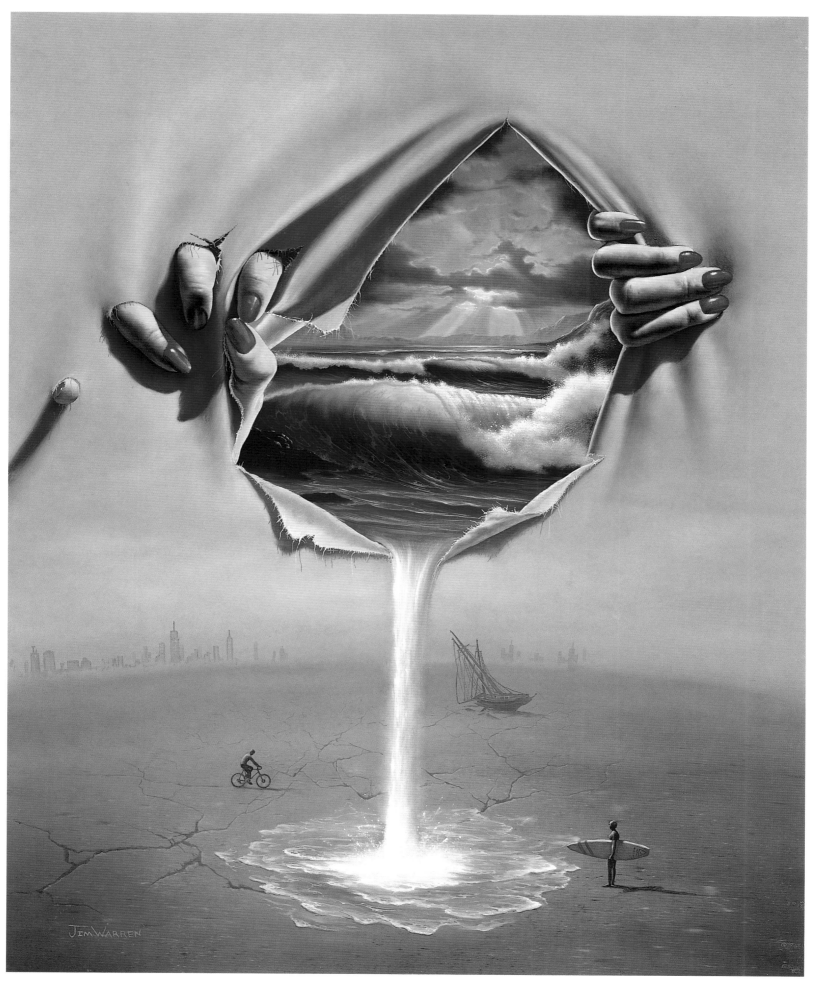

Waiting for the Rain

1993

61

Fearless 1982

5/2/97

Dear Jim Warren,

Hello! You probably don't remember me; Samantha Hamilton. I wrote you a letter a couple of years ago and you sent me a personally written letter plus an article with a picture of you and your lovely baby, and a package of cards signed by you which I thought everything was very nice. I am 12 now. In fact I turned 12 the 27th of Febuary. I love your paintings, they are very unique and beautiful. I especially like the one called "fearless". It says on the back you got the idea when, "You watched you got the idea when, "You watched your 2-year old daughter, Drew, run playfully toward a gnarling, slobbering dog and realized the truth of this painting." I would buy your paintings but I cannot afford them. But I can admire them. I am an artist too. of course I mostly just sketch. I do not do bizzare paintings like you. Here are 2 I think are the best of my collection of pictures. You may keep them if you like.

Another one of my favorites by you is "THE WAVE" I would like it very much if you would send me another one of your hand written letters Most artists or famous people will just send one of the copies that say the same thing and they send one to all of the fans that write. I understand the people are busy but at least they could sign the typed letters.

From,
Samantha
Hamilton

HEY JIM! WHAT'S UP?

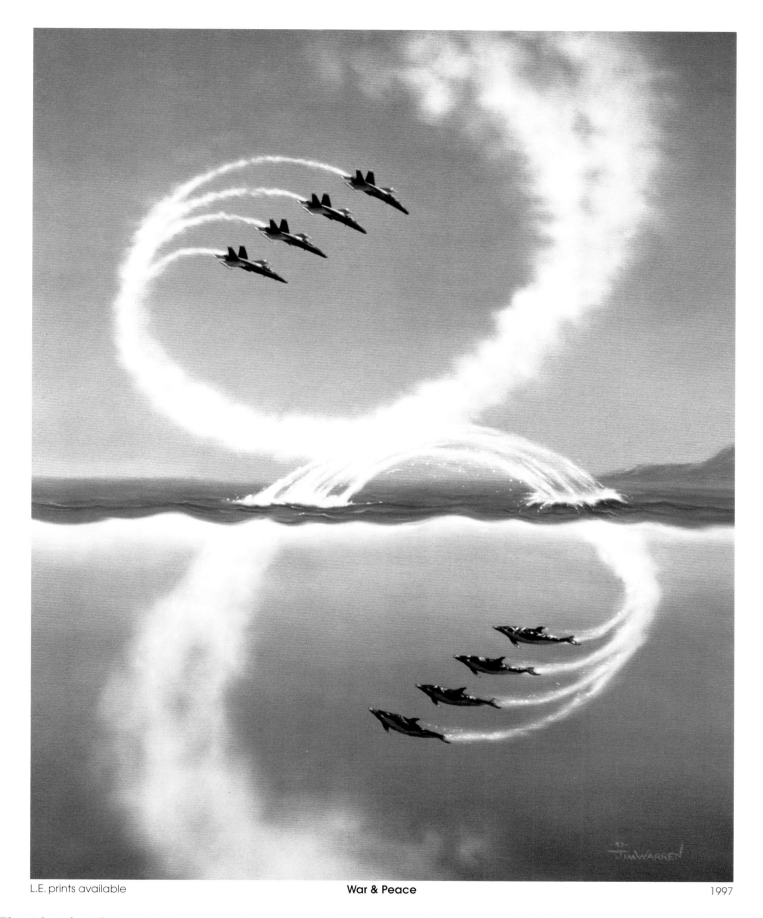

War & Peace 1997

The idea for this painting came to me one day while I was watching the Navy's Blue Angels perform at an air show at MacDill Air Force base in Tampa, Florida. I was struck by their simple grace and beauty, which I found to be remarkably similar to the grace and beauty of a group of dolphins swimming in the ocean. But even more striking was the contrast between what concepts each represented—war and peace. There was no particular message here, just an interesting observation which I felt compelled to paint.

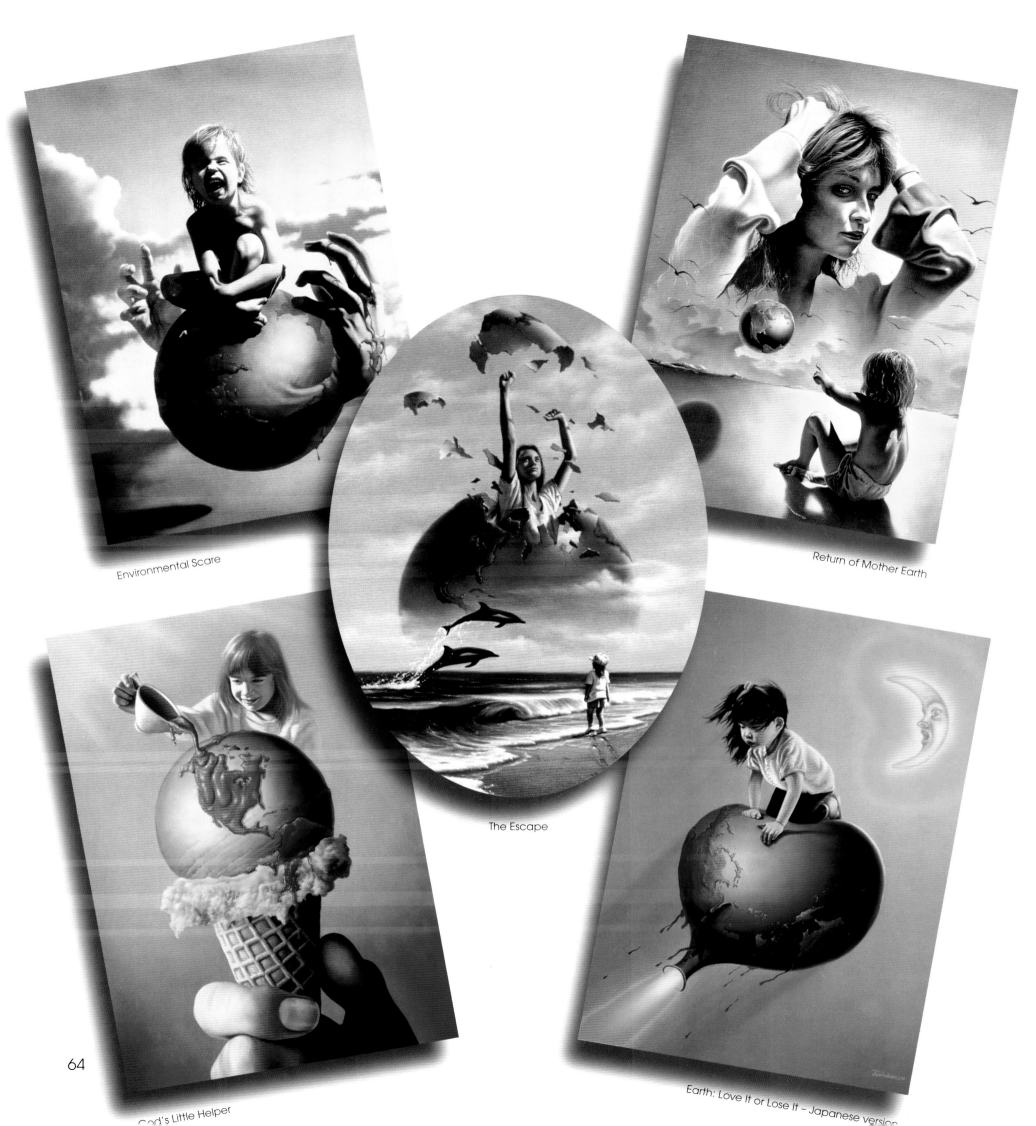

Environmental Scare

Return of Mother Earth

The Escape

God's Little Helper

Earth: Love It or Lose It – Japanese version

64

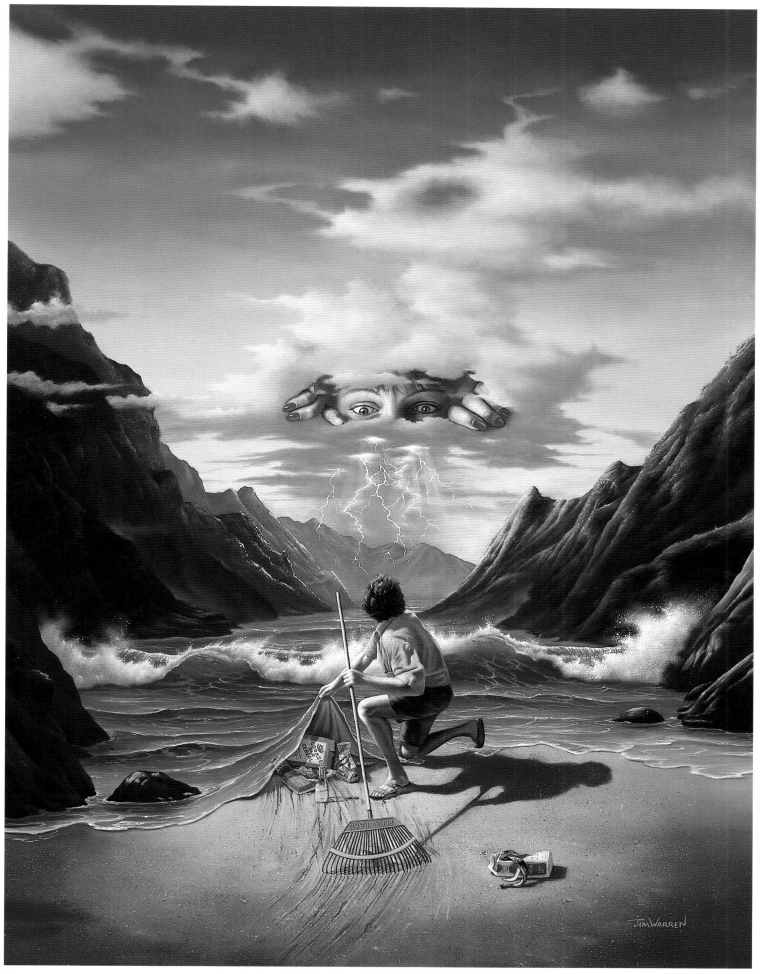

Don't Mess with Mother Nature

1994

65

Vacation

1992

66

Mysteries of Life

1992

67

"Sometimes simply the beauty of nature itself can be the best environmental message."
Jim Warren

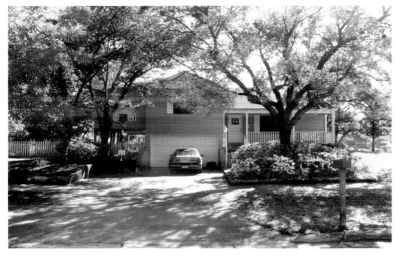

Jim's home in Clearwater, Florida

"Country Lane" was the first of my "Beauty of Nature" series. This particular painting was inspired by my new neighborhood in Florida where, sometimes, the lush, moss-covered trees are so enormous that they entirely cover the homes, leaving only an occasional mailbox as proof of the presence of civilization. This series was a refreshing new direction for me to go in, and I'm sure I'll continue with this project for some time. On the following page are several more paintings which were inspired by other places I have lived in and traveled to.

L.E. prints available

68

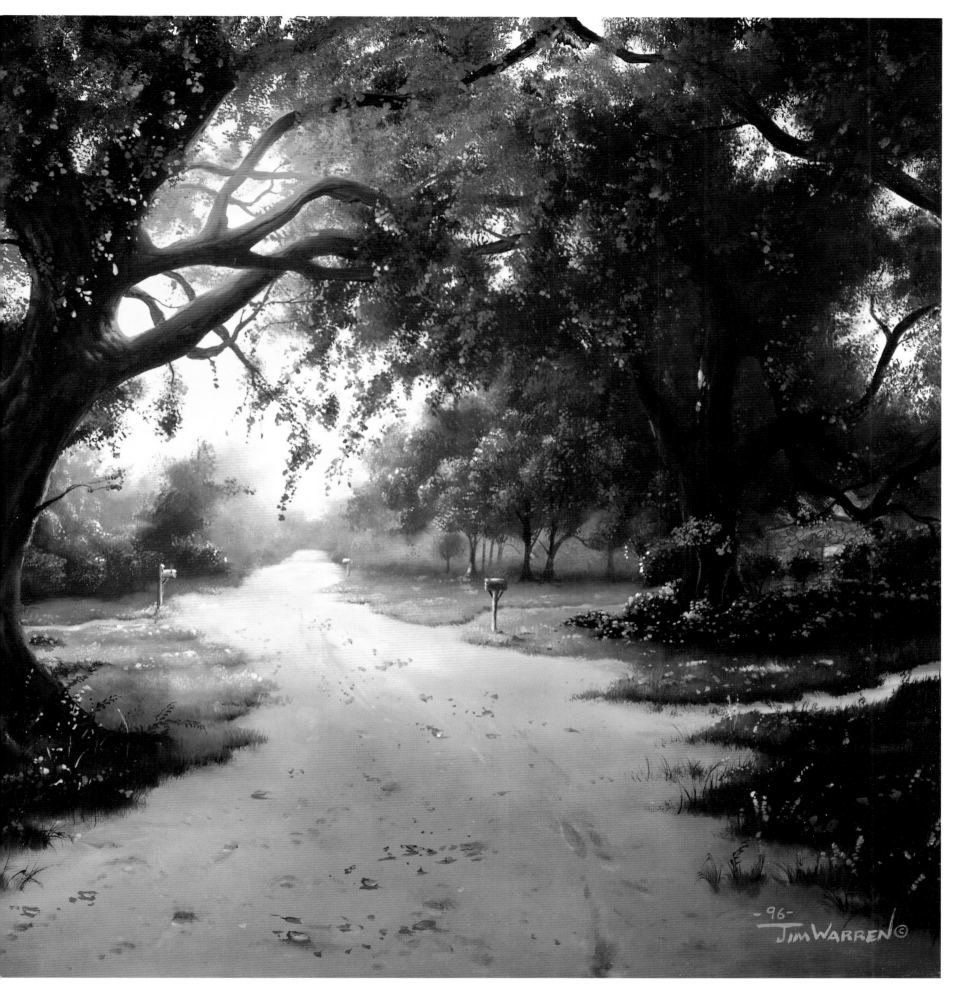

Country Lane

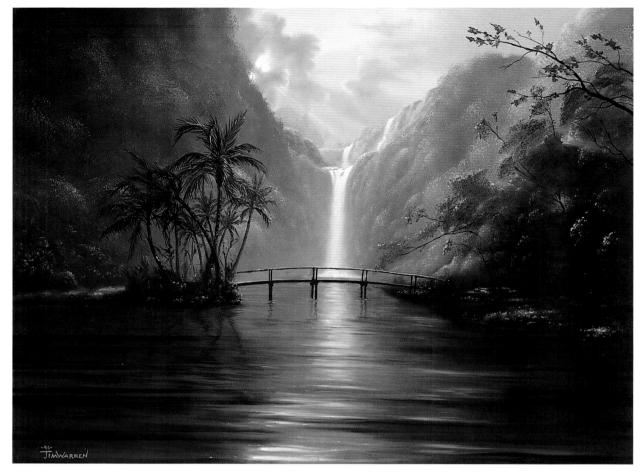

L.E. prints available **Reflections** 1997

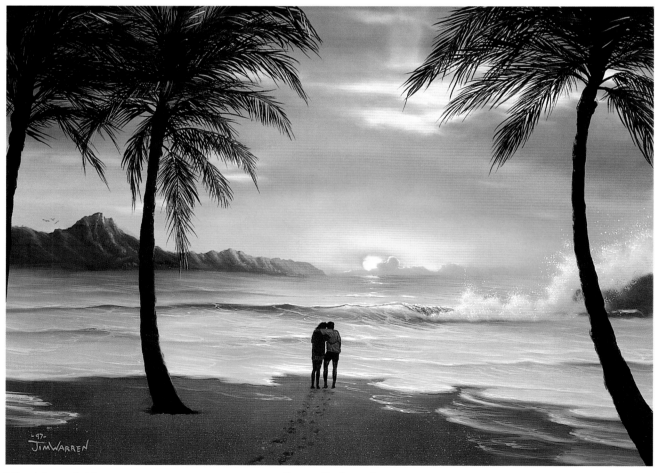

L.E. prints available **Romantic Sunset** 1997

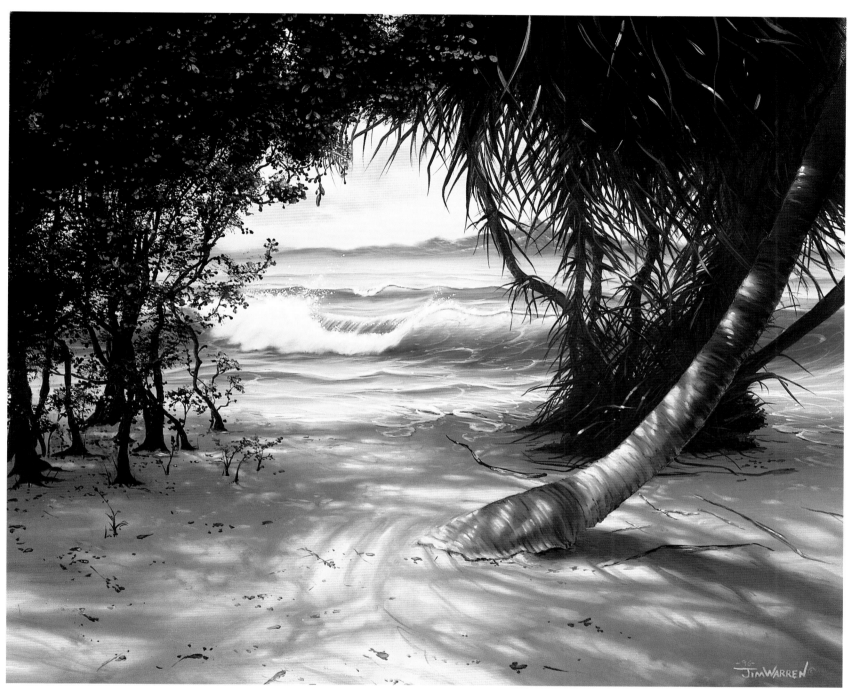

L.E. prints available **Caribbean View** 1997

"A beautiful painting on the wall can be the next best thing to a window with a view."

Jim Warren

L.E. prints available

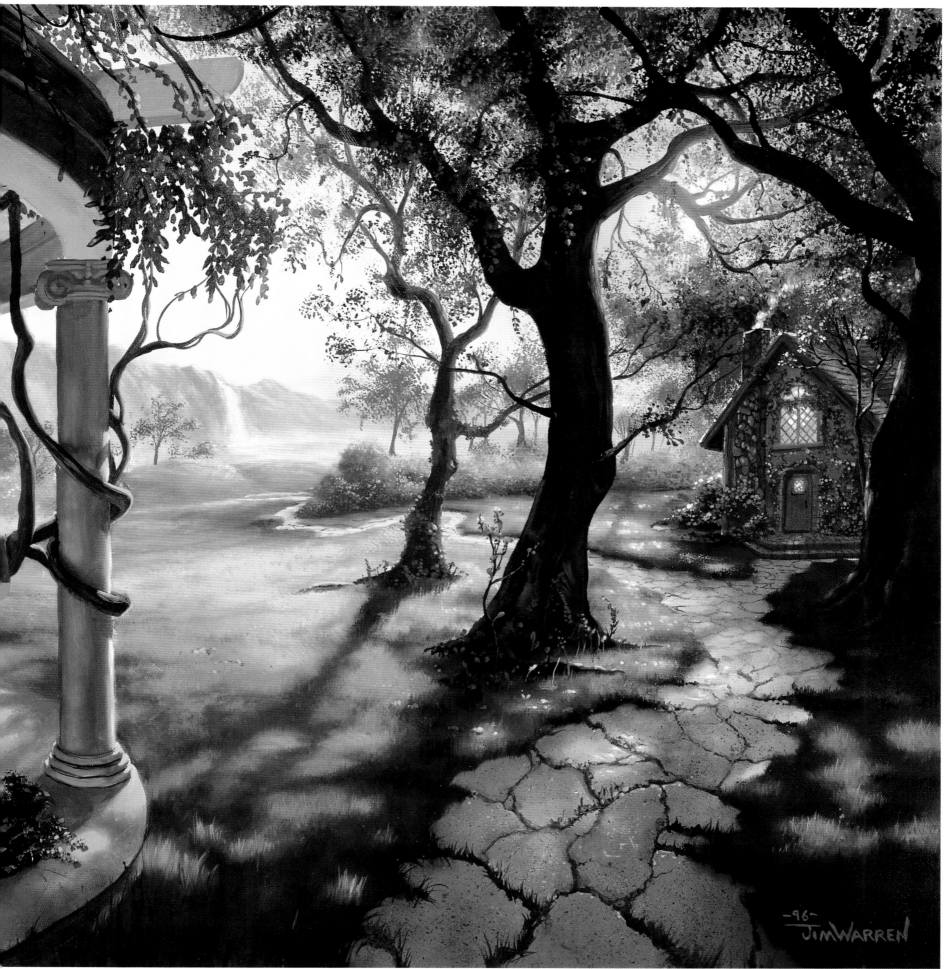

An Inviting Path

73

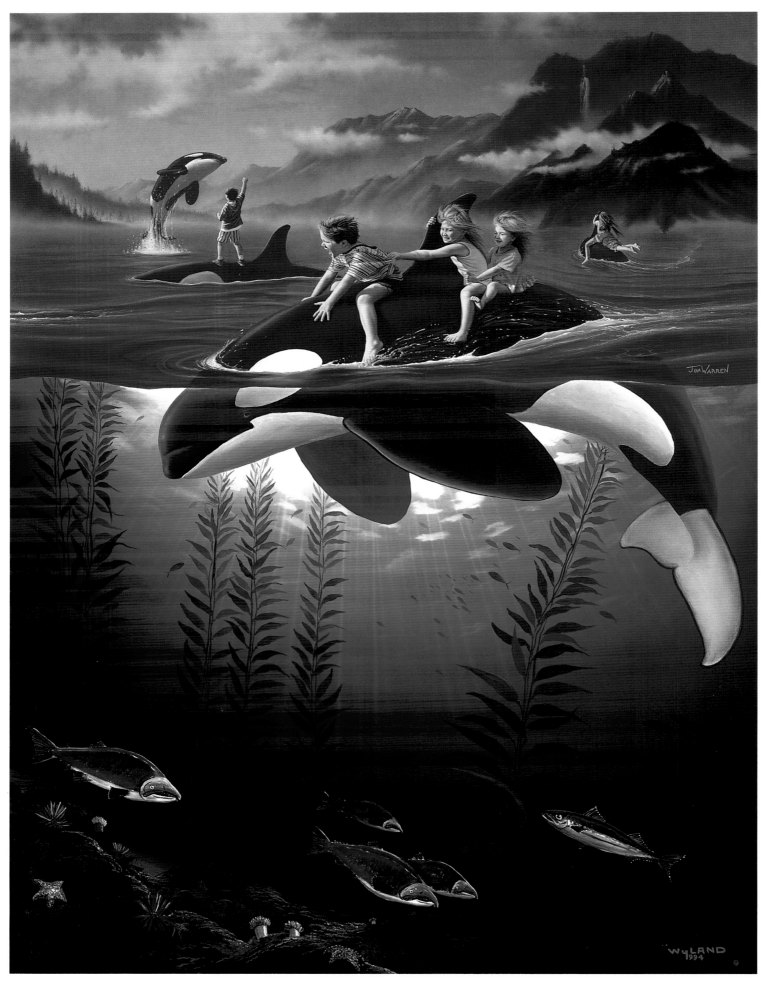

Whale Rides (Warren & Wyland)

1994

Collaborating with Wyland

I first heard of Wyland, the country's leading marine life artist, in 1990, when he came to my hometown, Long Beach. He was there to paint one of his famous Whaling Walls on the side of the Long Beach Arena. This marine life mural would become the largest in the world, according to the Guinness Book of World Records.

Some members of the community and the city council were in an uproar over this. The local newspaper was criticizing him one day and praising and supporting him the next. He brought controversy to Long Beach simply by painting the beautiful wonders of the sea on a blank white wall. I was impressed at the enormous impact he created in the art world, which I felt needed an injection of excitement.

A year later, while exhibiting at the L.A. Art Expo, Wyland approached me. "Would you be interested in collaborating on a painting?" he asked. Having never done a collaboration, but always ready for a challenge, I said, "Sure!" We spoke for awhile and decided that a mermaid would be a good choice for the subject of our painting, as his specialty is marine life, and mine is people.

Being accustomed to the world of illustration where the motto is, "We need it yesterday," I returned the next day with a color sketch for the painting. I think Wyland was impressed with my ambition and speed. But not to

Jim Warren & Wyland 1996

be outdone, he suggested that we do *two* collaborations and unveil them at his winter shows in the California Wyland Galleries. These shows were to open in less than a month. That meant finishing my half of the two paintings, giving them to Wyland to paint his half of each, and then getting them framed and hung, all in just a few weeks. My first thought was, "That's nuts!" But, I smiled and said to Wyland, "Let's do it!"

Two hours after the show started, the paintings, "Dolphin Rides" and "Mermaid's Dream," arrived at the gallery. The room was filled with anxiously awaiting public. We unveiled the collaborations, which were enthusiastically received.

Since that day, Wyland and I have done several more of these which have been published as limited edition prints. They hang in galleries and homes all over the world.

Dolphin Rides

When I started working on "Dolphin Rides," I had little time to plan or prepare. I had rarely painted dolphins before, especially those with children riding on them. I felt that this painting should be done realistically, but at the same time it should be slightly unreal in its subject matter, almost fantasy. I've always loved to do paintings of children doing what they do best - using their imaginations.

I gathered up my niece and nephew and a few of their friends, my cousin, my neighbors, and even my own daughter who was six months old at the time. Before I left my house to photograph them, I realized I needed one of the girls to be riding a dolphin, and it had to look convincing. I went to our backyard pool, pulled my boogie board from the water and cut a dolphin fin out of it with a knife. When it was finished, I took it to where the kids were waiting to be photographed, put the fin on my brother-in-law's back, placed my cousin on his back and told my brother-in-law to "...jump like a dolphin." I got the shots I needed and, later, painted my cousin riding a "real" dolphin.

Based on my initial sketch, I then posed the other kids to fit the "characters" which I had drawn out beforehand. The original sketch was used like a director might use a movie script. All the children were part of the overall concept called, "Dolphin Rides."

But it isn't only the children that make "Dolphin Rides" a classic; it's also Wyland's ability to give character to his dolphins and other marine life, as if they are as alive and animated as the children they are playing with.

More notes on the painting:

- This being our first collaboration, I had originally painted a rock in the middle of the water, not realizing what effect this would have on Wyland's half. Wyland fretted for hours. And then, in the middle of the night, the solution came to him. He decided to get surrealistic and turn the rock into a sea turtle.

- Notice the tuna, one of dolphins' favorite meals, swimming peacefully by as the dolphins are busy at play.

- Another Wyland touch is the quarter on the sea floor, obviously dropped by one of the children.

Jim's daughter Drew (6 months) & niece, Cristin

Brother-in-law, Laddie, & cousin, Haley

76

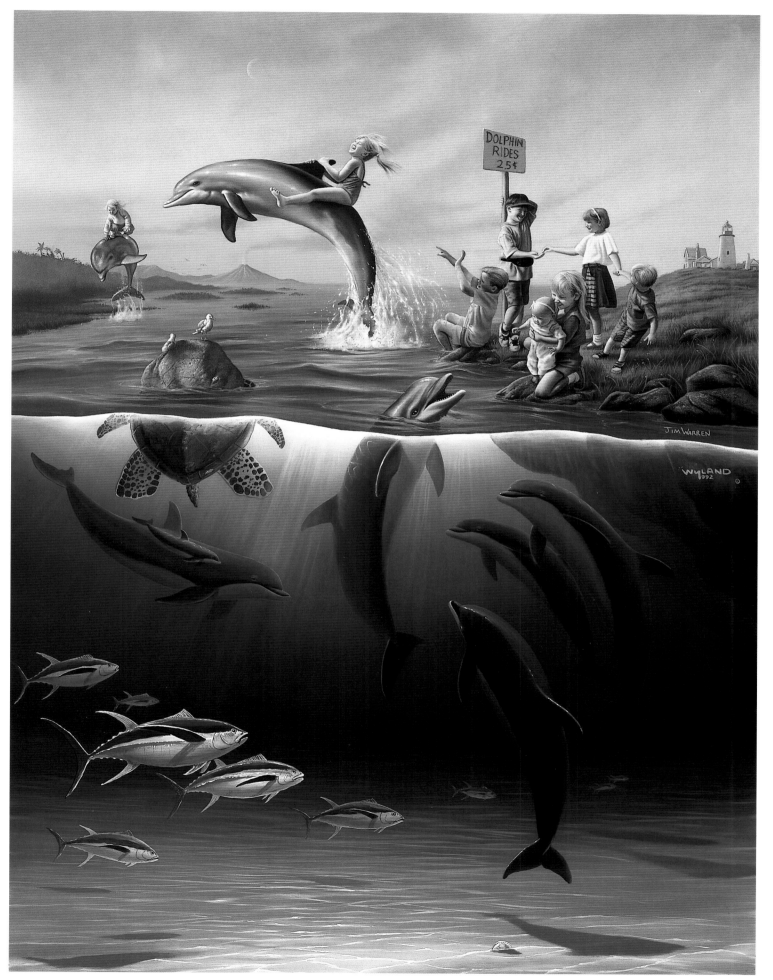

Dolphin Rides (Warren & Wyland)

1992

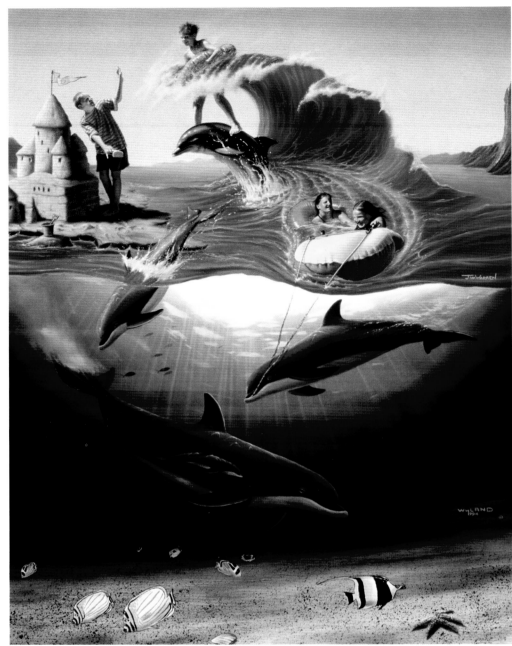

Wild Ride – Commissioned portrait 1993

Drew Warren modeling as mermaid

Original "The Littlest Mermaid" sketch

Art Warren steals the spotlight with a song, San Francisco, 1996

Drew (The Littlest Mermaid) with her dad
at unveiling in Hawaii, 1994

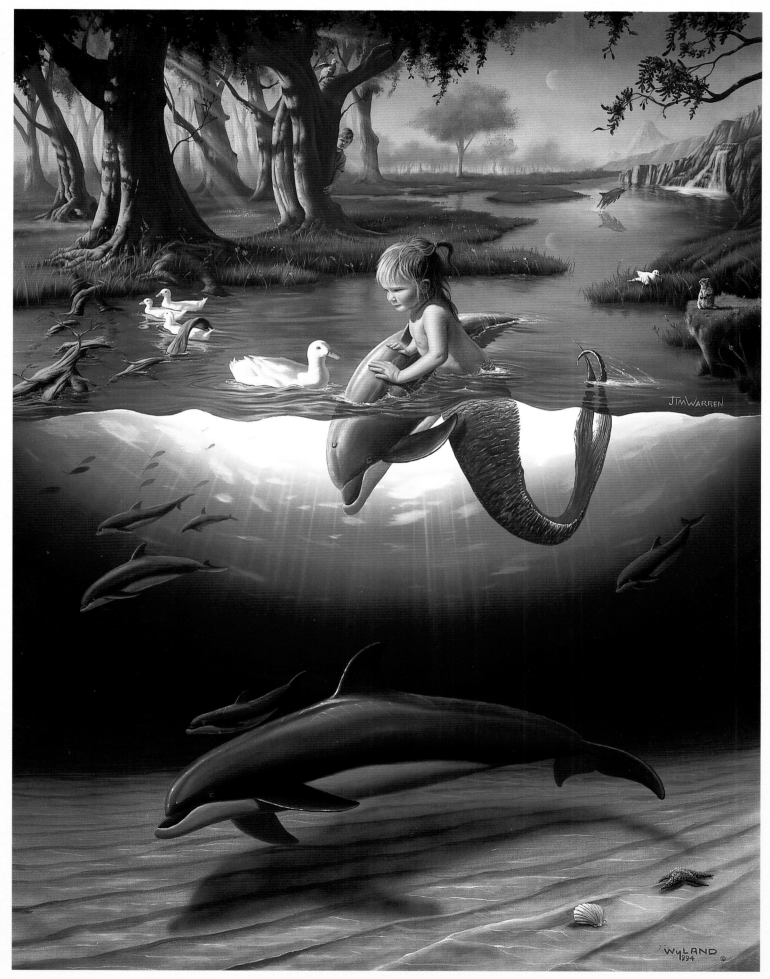

The Littlest Mermaid (Warren & Wyland)

1994

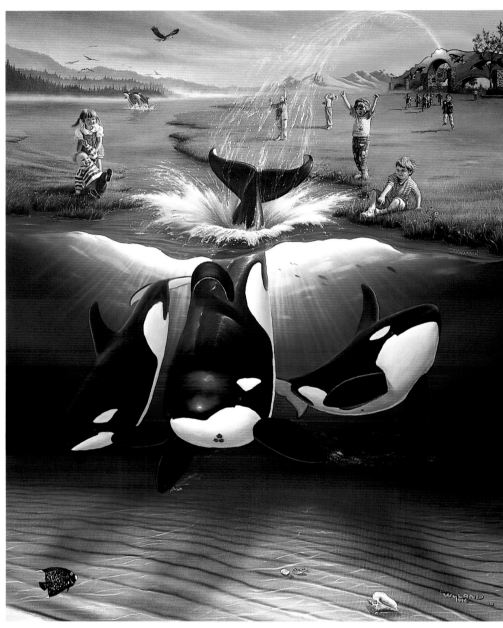

L.E. prints available **Keiko's Dream (Warren & Wyland)** 1995

Art Warren modeling

Jett Travolta & Drew Warren during
modeling session for "Keiko's Dream"

The idea for "Keiko's Dream" came to me one day in 1995 while watching "Entertainment Tonight." Featured on the show were Wyland and Keiko, the whale (of "Free Willy" fame.)

Wyland had just completed one of his remarkable murals in Mexico City, this time featuring Keiko. While the killer whale was regaining his health, he was to be sent from Mexico to a more spacious habitat in Oregon and, eventually, he was to be set free in the natural waters of Iceland. My first thought was, "This calls for a commemorative collaboration between Wyland and me, to mark the occasion."

As usual, I started with the models: my daughter, Drew, and some of her school friends, including Kathryn, Cal, and Jett. And, there was newcomer, Art, my son. After the photo shoot, I painted my half of the canvas, and Wyland painted his.

But the star of the show was Keiko, who was released from Mexico City in January of 1996, on the day Wyland completed the painting.

80

Rebecca modeling

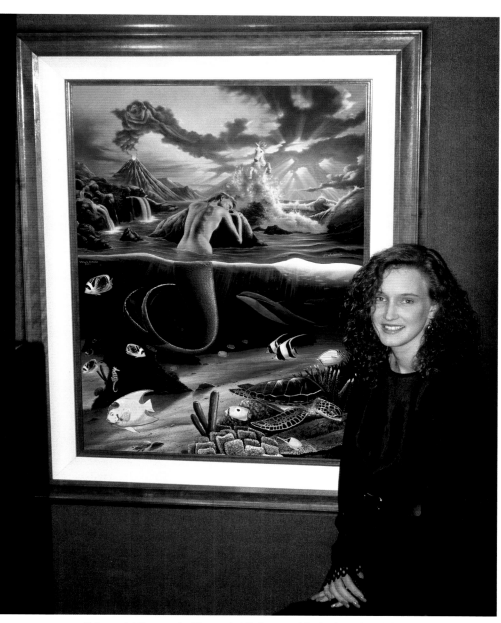

"Mermaid Dreams" with model, Rebecca (Jim's step-daughter) 1996

Jim & Wyland with half-finished
"Mermaid's Dream," 1992

How we collaborate

It is quite common for performing artists to work together, but very rare for painters. People often ask, "How do two artists paint on one canvas?" Wyland and I begin a collaboration by talking about a subject, like mermaids or children. These are brief conversations over the telephone or at a restaurant. We might do a little doodle on a napkin and say, "How about...?" "Yeah...," goes the conversation. "And, what if we...?" Very simple.

I then begin the actual painting by taking a 36 X 48 inch canvas and drawing a water line which I only paint above. When my painting above the line is complete, I send it to Wyland who paints his underwater scene into the blank, lower space. A single dolphin or whale might be half his work and half mine. We neither observe each other painting, nor concern ourselves with what the other is doing. Wyland sometimes jokes that between the two of us we have enough brain cells to complete a whole painting! At least I *think* he's joking...

81

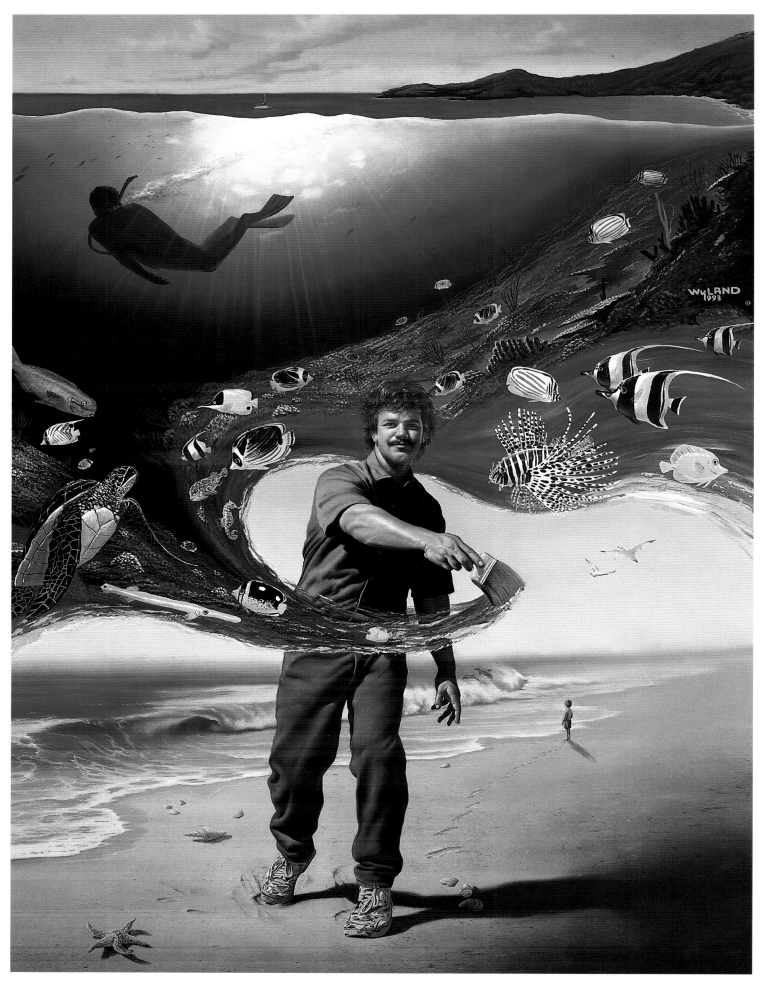

Another Day at the Office (Portrait of Wyland by Jim Warren and Wyland) 1994

Portraits

I call my portraits, "personalized paintings," because they are fairly radical departures from what are considered classic portraits. The client requests I get are extremely varied, and I try to provide what is wanted. First, I consult the client to see if he has a concept of the painting. If he doesn't, then I talk with him and find out about the person whose portrait I'm doing. What is the person like? What are their interests? And, do my clients want something wild and surreal or more calm and serene? For example, I might be approached by parents who like my fantasy art, and they have children who are very active in sports. The family also enjoys the ocean. I might incorporate the children playing some type of sports in the ocean, along with other sea creatures woven into the picture.

Then I would meet the children and get twenty or thirty shots of them in various positions. To get a natural pose, I get them to act out the scenario which is going to be the final portrait. When the photos are complete, I do an initial sketch, get my clients' approval, and they soon have a personalized painting with their children as the subjects.

The photography stage is important when doing a portrait because the individual behind the face must be captured. Probably the most important and most difficult facet of portraiture is communicating the essence of the subject. Everyone has their own spark of individuality, and it's my job, in doing a portrait, to make sure that that special individual shines through.

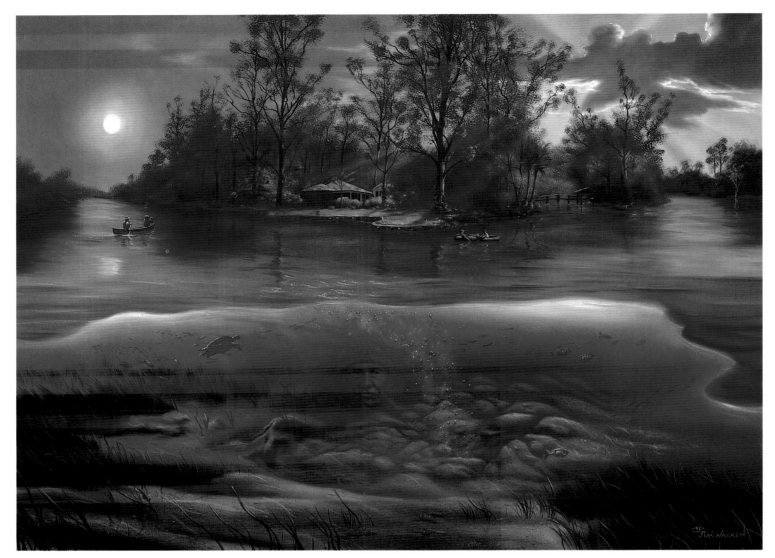

Rainbow Springs 1995

"Rainbow Springs" was an unusual portrait for me. Previously, I had specialized in painting people. But for this project, I was commissioned by Dr. Joy Byrd to paint her home and the length of the river that flows by it. I took a boat ride from one end to the other, photographing anything that caught my eye, including the underwater springs. I then painted not a photographic image of the river, but the overall essence of the whole river as I experienced it. There is much Indian history on this river, which is why my client requested the spirit of an Indian chief in the portrait.

Jim doing research for "Rainbow Springs"

Photo shoot for Roberts portrait

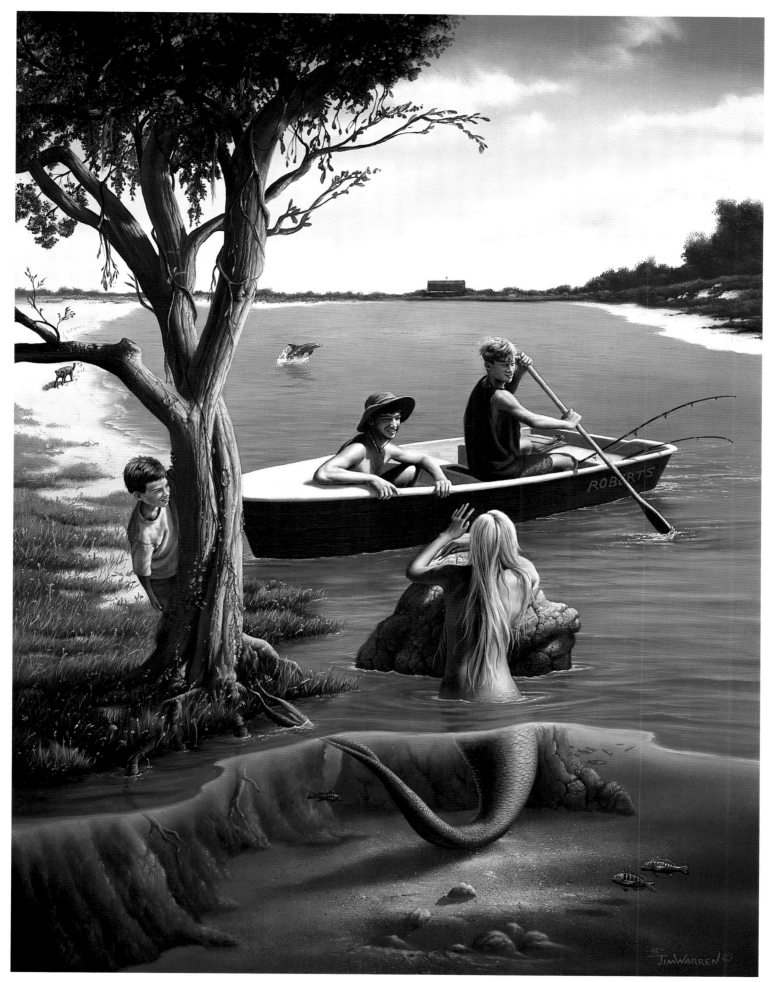

Surprise Encounter (Portrait for the Roberts) 1995

This portrait was done for the actor, Leo Burmester (The Abyss,) and is more than just a portrait of his family. It includes their cat, dog, house, dragonflies, and even their bees which Leo raises in his spare time.

←

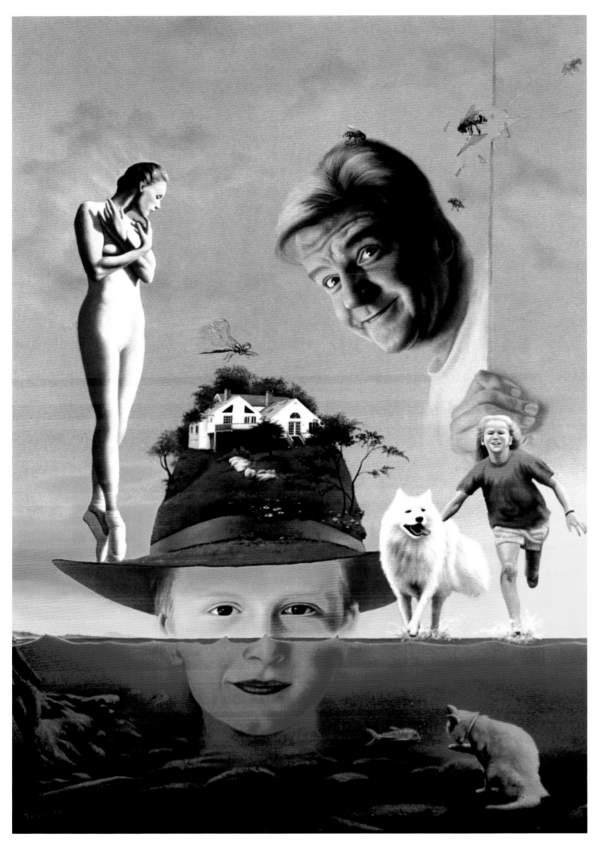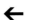

Portrait for Leo Burmester 1990

(Opposite page) I have always admired Juliette as a person and an actress. I enjoy watching her in movies such as "Christmas Vacation", "Cape Fear", and others. When I first talked to her about doing her portrait, she made it clear that she wanted me to paint my "interpretation" of her. I had many interesting ideas before the photo shoot and even a title: "Juliette—inside and out." During the photo shoot, I was so struck by her simple, natural beauty that I threw out all my original ideas. But I kept the title, as it seemed to add to the mystery and symbolism of the painting. I like to think of this portrait as being my modern-day "Mona Lisa." (1997)

→

Juliette

Inside and Out, 1997

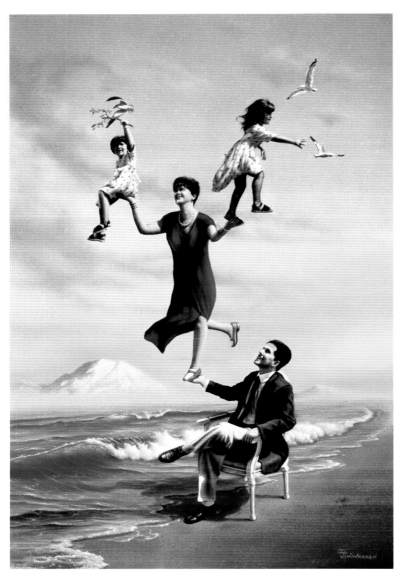

Family portrait for Dr. Antonio Otero, D.D.S. 1995

Secret Spot (portrait of Robin Poznikoff, rocket scientist & surfer) 1993

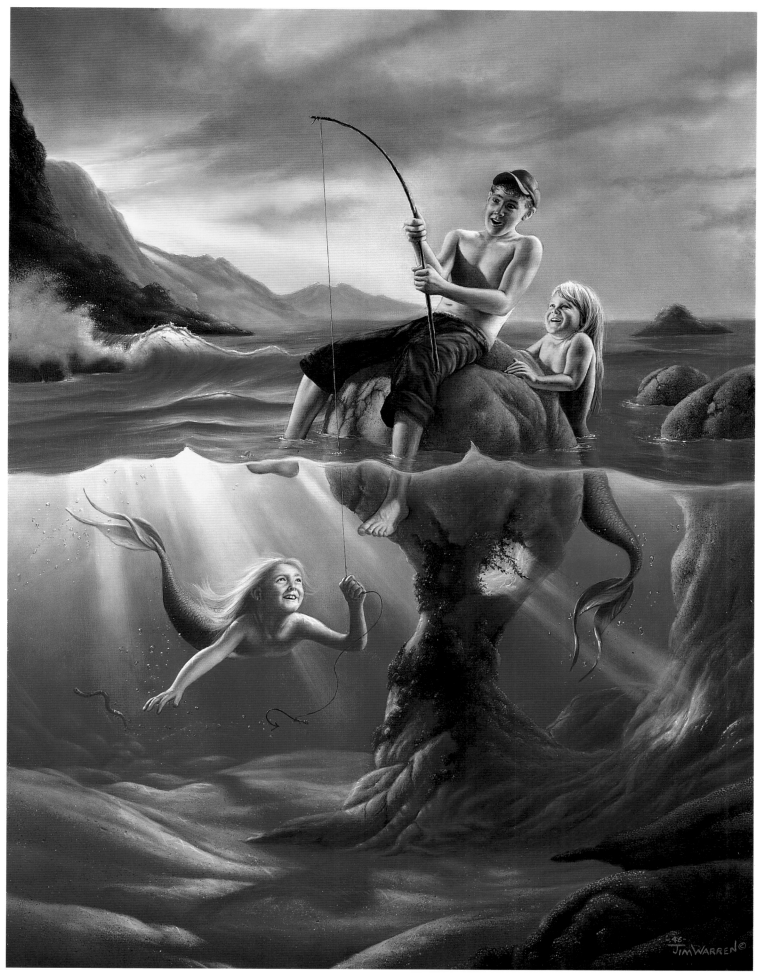

Catch of the Day (portrait for Greg Shaffer, gallery owner) 1996

Portrait for Jean Hornez 1991

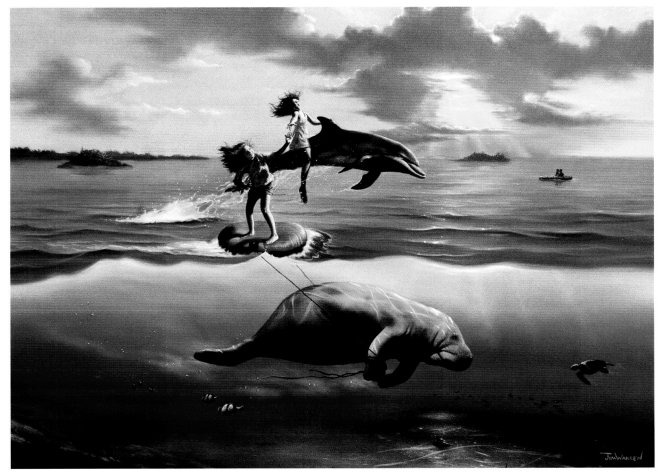

Portrait for Mary Lou Johnson, marriage counselor 1997

Sweet Dreams (Portrait for Leonard & LaRue Katzman,
Executive Producer of "Dallas" and other TV shows) 1990

Michael Parnell, the CEO of Oakley Sunglasses, commissioned me to do a portrait of his children as a surprise for his wife. In order to get the needed photographs of the children in their home environment, I flew to Seattle and then was picked up in Michael's private plane and flown to his home on a small island off the coast of Washington.

Portrait for Michael Parnell 1995

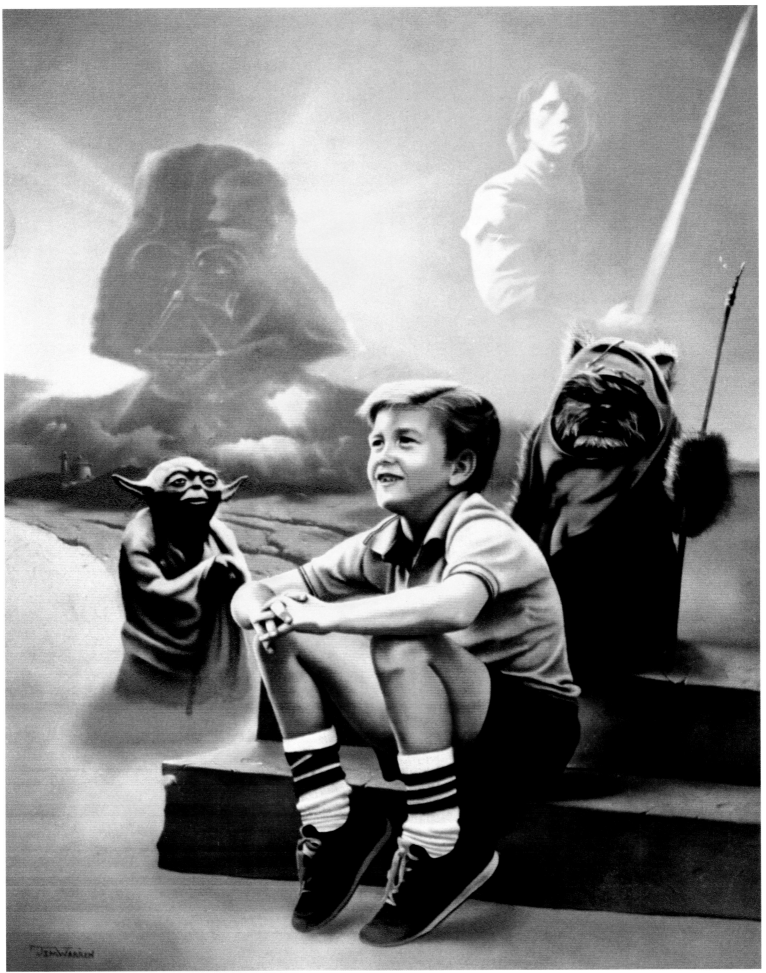

Portrait of Raymond

1987

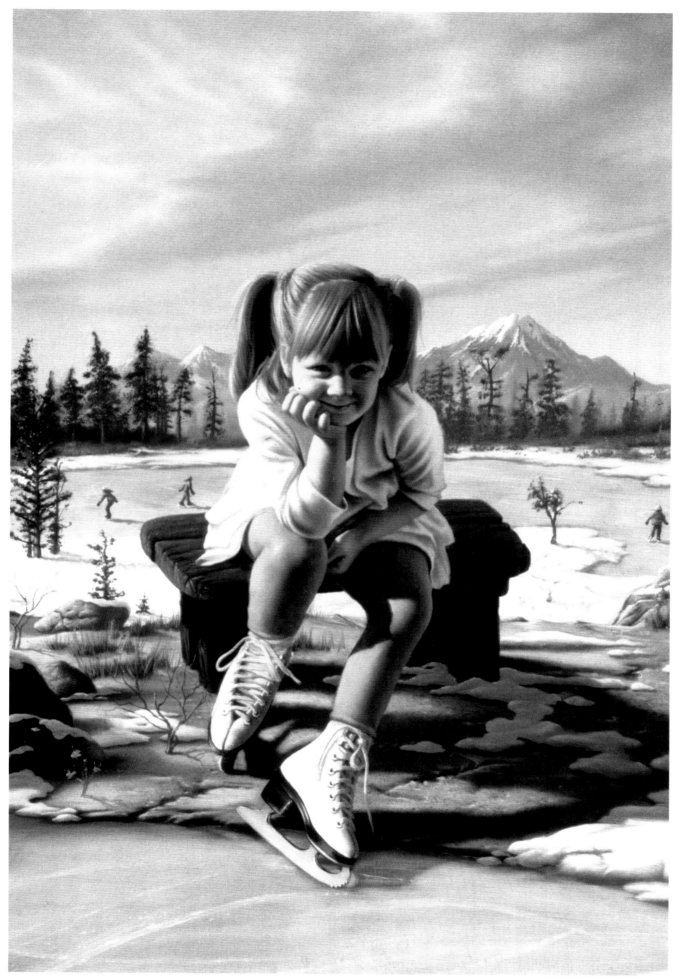

Portrait of Haley 1991

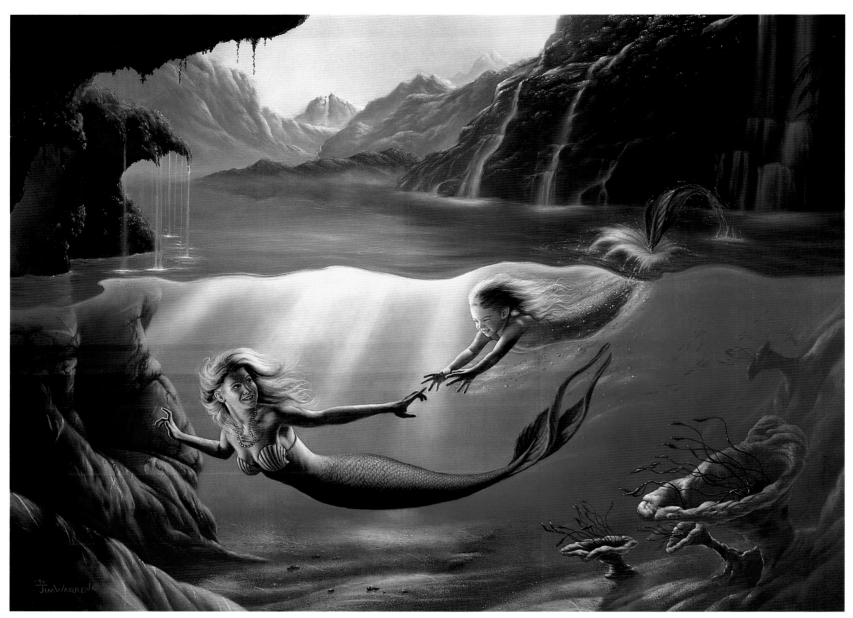

L.E. prints available **Mother & Child** 1996

Models for "Mother & Child"
Ann & daughter, Tina

Jim with Marla Maples-Trump
at art show, Wyland Galleries,
Laguna Beach, California, 1997

94

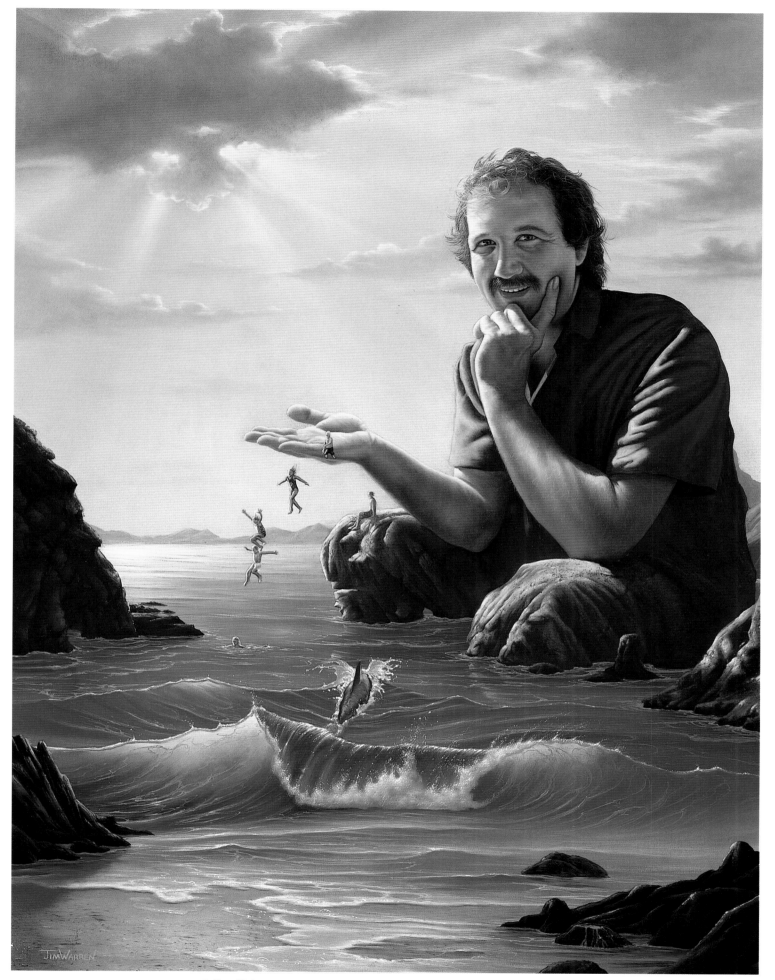

Father Nature (portrait for Ron King, president of Blue & White Industries)

1994

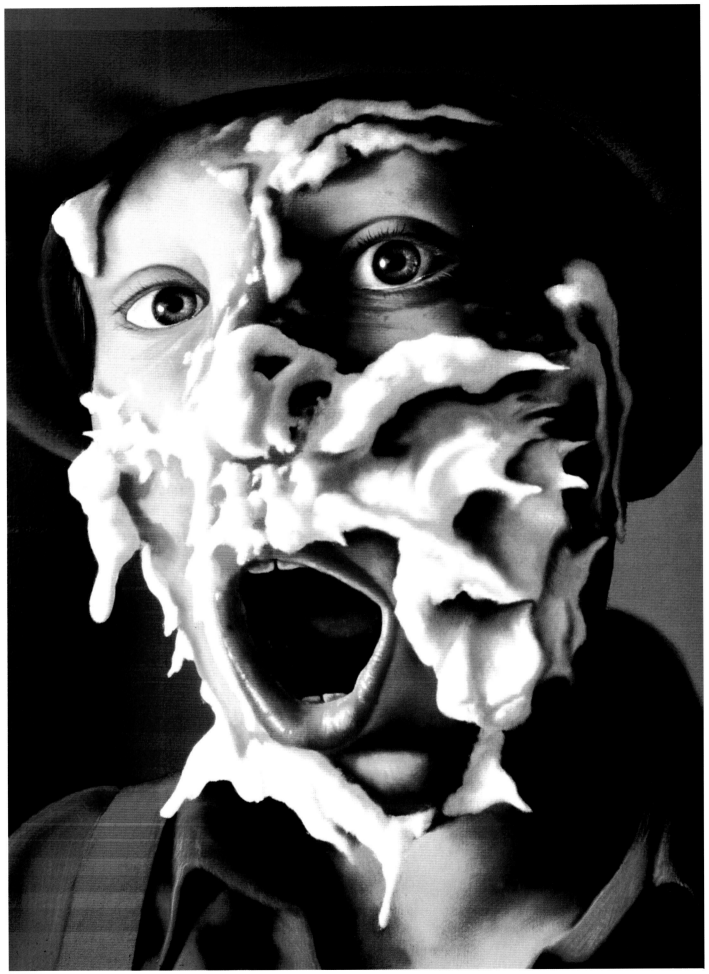

Random House book cover, "Dogs Don't Tell Jokes" 1988

Illustration

I don't actually consider myself so much an illustrator as an artist who does illustrations, using my natural style of art. Because it is bold, eye-catching and often tells its own story, my style of fine art lends itself well to certain illustration.

In high school, I drew album cover designs and thought how much fun it would be to see my paintings in a music store. In 1976, I did my first album cover for the Billy Cobham/George Duke Band. I soon did more albums, then magazines, movie and tv show ads, and posters. The demand for these was sporadic at first, something I did when I wasn't doing my own paintings. But in 1986, I began painting covers for pocket books.

As my art was already very illustrative, it was perfect for the book industry. Over the next five years, I painted illustrations almost exclusively and, to date, have produced over two hundred book covers as well as other illustrations, ranging from paintings for entertainment companies, such as Universal Studios and Capitol Records, to corporate advertising for companies, such as Mazda.

Working in illustration, I had a great deal of fun, was challenged by the form, and gained valuable technical experience, but I had not set out to be a full time illustrator. In 1989, I decided to get back to my roots and begin painting subjects which inspired me. At the time, I was interested in environmental theme paintings which were becoming enormously successful. As I returned to fine art, I became more selective with the illustrations I chose to do.

I've included some of my favorites in this chapter.

One morning in 1980, I had a call from the art director of Capitol Records. He said he'd seen my work and wanted me to do a painting for Bob Seger's new album. Seger had said that he wanted horses for the cover. I told him that I didn't paint horses; my specialty was people. Not to be put off, however, he said, "You can do it. I know you can." I reluctantly agreed, completed my first painting of horses, and sent it off to Capitol Records.

Over the next year, Seger's album, "Against the Wind," went to number one on the music charts which, of course, pleased me. Then at the end of 1981, I was working in my studio when the phone rang. The Art Director for Capitol greeted me excitedly and said, "Congratulations, we won!"

"We won?" I asked. "Won what?"

"You mean you didn't see the Grammy's?" he asked, in disbelief.

I said, "Not all of it."

"We won Best Album Cover for 1980!"

I was, of course, surprised by this, but I also felt a certain pride that I had done it using horses which was a completely new subject for me. It was an exciting experience and the successful conclusion to one of my first dreams as an artist: to paint record album covers.

Signing Bob Seger album cover for young fan

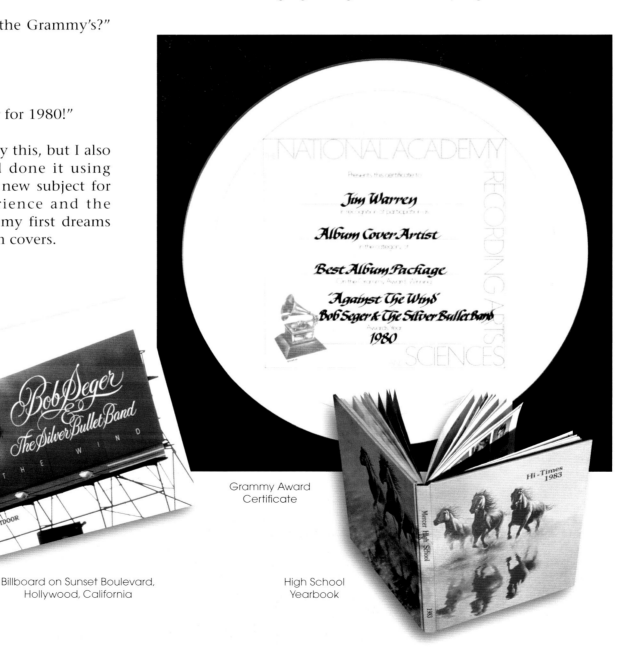

Billboard on Sunset Boulevard, Hollywood, California

Grammy Award Certificate

High School Yearbook

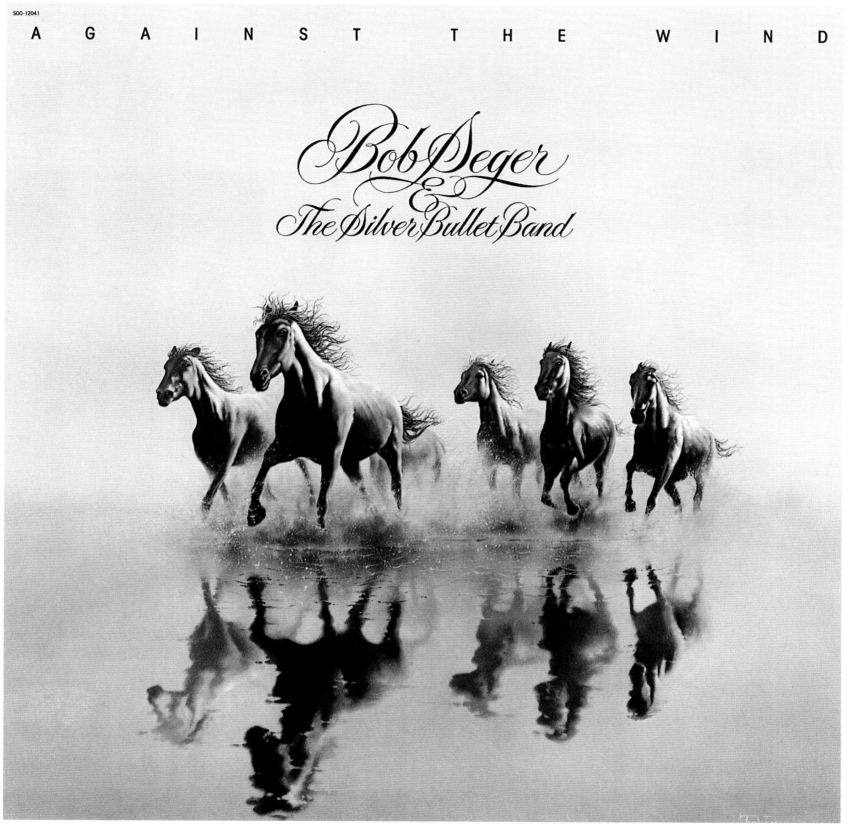

AGAINST THE WIND

Bob Seger
& The Silver Bullet Band

Album cover for Bob Seger

1980

"Jim is one of those artists a publisher/art director truly cherishes. He has vision, imagination, and talent. And his skills are such that when you really get into a jam, he can, and will, save your schedule every time.

"As you will notice, if you look at the DAW cover art included here, Jim's style, wit, and creativity are perfectly suited to the theme anthology. Because of the variety of stories in this type book, it is often hard for an artist to accurately convey the full scope of the tales within. However, this has not proven to be a problem for Jim. The subject matter he's illustrated for us over the years runs the gamut from fantasy to horror to science fiction, taking in such diverse subjects as dinosaurs, witches, Sherlock Holmes, and tabloid insanity, and visualizing them in completely new and very evocative ways. From real to surreal, from the broad canvas of imagery to those extra little Jim Warren details—like using a blender to help whip up a witches' brew on "Witch Fantastic," or having an alien hand holding the tabloid on "Alien Pregnant by Elvis." It's all there for the viewer to behold.

"So, what are you waiting for? You know how many words a picture is worth. So, stop reading, start beholding and enjoy."

Sheila Gilbert, DAW Books

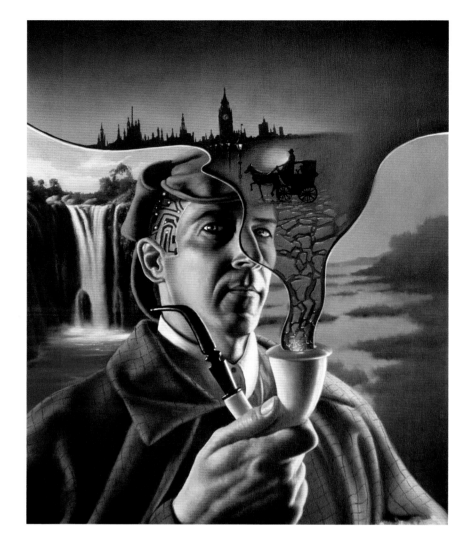

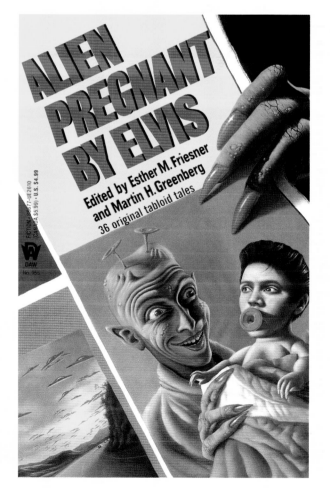

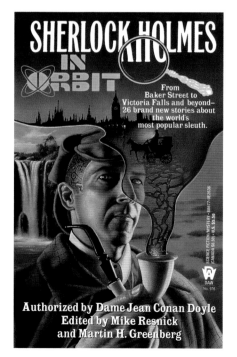

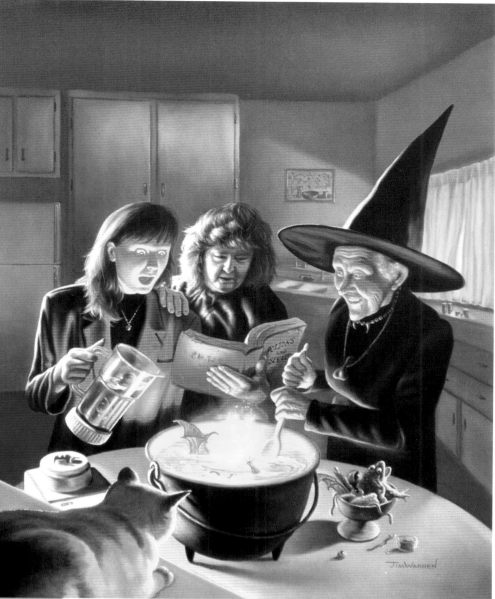

All characters should have life and depth...the kind of depth that

Love Lost!

forces the viewer to take a minute of concentration to absorb them.

1) Olive skinned people wearing purple hoods and capes of white or
 purple(half of the capes white, the other half purple).

 all together

2) A pretty, laughing, little girl of 3 or 4 years old, on a seesaw.

3) Paisley lawns with yellow dandelions and lots of violets.

4) An elderly black man (55+ years old) sitting on a step, crying.

5) Blue sky backround with fluffy clouds

6) An exotic, beautiful woman wearing a black cape and raspberry beret.

little girl ?

7) A blond girl covered in lace and eating an ice cream cone.

8) A laughing woman dressed in black who resembles Clara Bow.
 Hysterically laughing.

 clara bow!

9) An obese, bearded man covered with tattoos, affectionately hugging
 a tiger.

 (ken)

10) A small body of water on a pier. An old woman crying into a hand-
 kerchief at dockside, over a love lost.

 ? Love lost

11) A ladder leading from the water into one of the clouds in the sky.

12) 2 or 3 people wearing black button-downs playing tambourines. Their
 hair should be shorter on one side.

13) A naked black baby running with an American flag.

14) A small Russian fighter jet flying through the sky. This should
 not be a major focal point.)

15) Doves flying and walking.

16) A clown juggling two balls, a globe.

Peir + lawns?

Original instructions and notes for "Around the World in a Day" (opposite page)

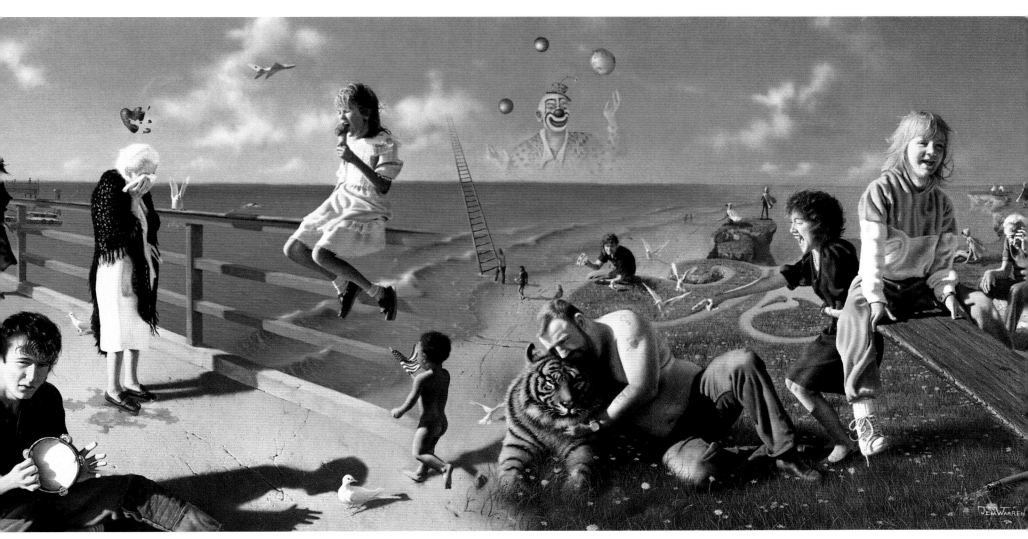

Around the World in a Day

Prince's management contacted me to do this painting. They gave me little information other than a one page sheet with thirteen instructions on it such as, "...a fat man hugging a tiger," and "...two men with hair shorter on one side, playing the tambourine." I had a few questions but was told, "...use your imagination." So, I did. I enjoyed the freedom he gave me with the painting and felt that it made for a great collaboration between artist and musician.

Jim's neighbor, Ken, as model

Halfway through the painting, I was told that Prince wanted to see it in Cincinnati, Ohio. I explained that I wasn't finished and the paint was still wet. They explained further that the first thing Prince wanted to see when he woke up was my painting. So I boxed up the painting, put it in the airplane in the seat next to mine, and we (the painting and I) went to Cincinnati. Two bodyguards came to my room and picked it up. The next day, it returned with simple instructions: "Finish it." I did and was told he loved it.

I was once asked if I get nightmares when I paint scary stuff. I answered,

"Real men don't get nightmares!"

"Beverly Hills 90210" TV Show

"Roseanne" TV Show

Poster

HORROR

Landmark Calendar

STUART FRIEDMAN
Visions of blood just danced in his head.
Maniac

Book Cover

NBC News

104

"The Feeding," bookcover

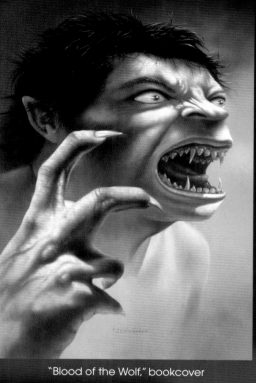
"Blood of the Wolf," bookcover

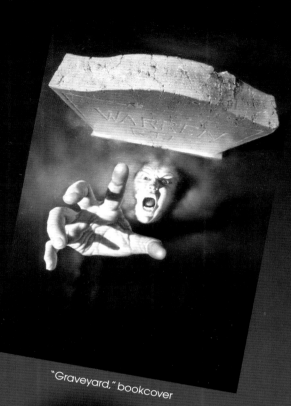
"Graveyard," bookcover

I half-jokingly call this painting my family portrait. The models include my mom, dad, niece, my wife's grandma and, of course, me.

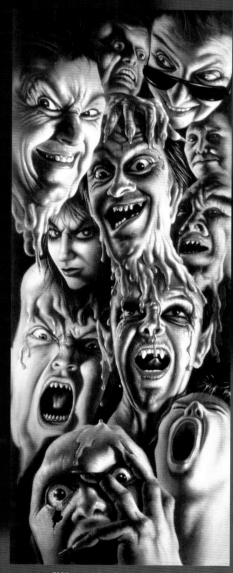
"Waxworks," movie poster

"Weave World"

"Jim is wonderfully specific in his details. He has brought form to some of my favorite nightmares."

Clive Barker

THE DAZZLING NATIONAL BESTSELLER!

THE FANTASY CLASSIC

CLIVE BARKER

WEAVEWORLD

AN EPIC ADVENTURE OF THE IMAGINATION

POCKET BOOKS

"He's better than I am now." —Stephen King

CLIVE BARKER
THE NEW MASTER OF HORROR

IN THE FLESH

TALES OF TERROR BY

CLIVE BARKER

THE INHUMAN CONDITION

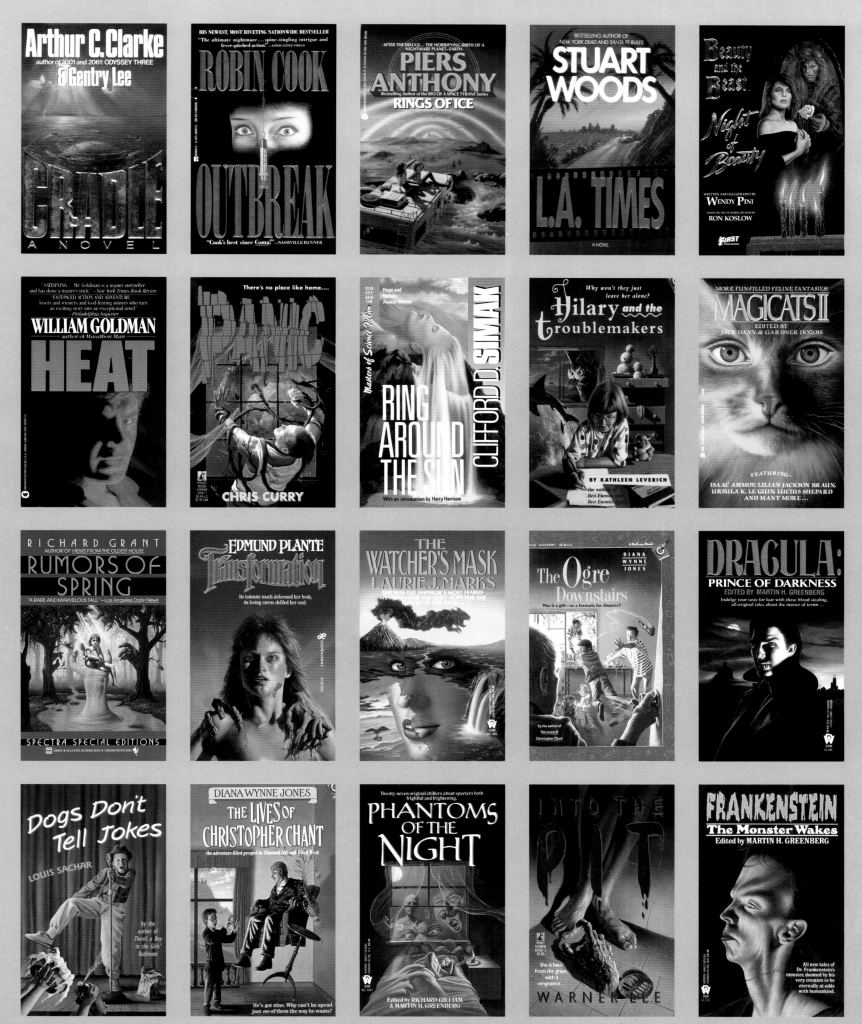

A sampling of the over 200 book covers created by Jim Warren

Ironically, this was the last painting I completed before moving from southern California where I was born and raised. In fact, the painting was being picked up for delivery as our moving van was being loaded!

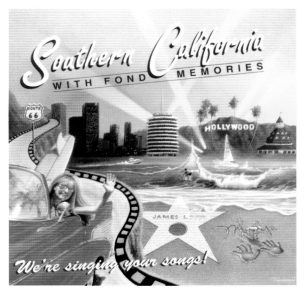

CD cover

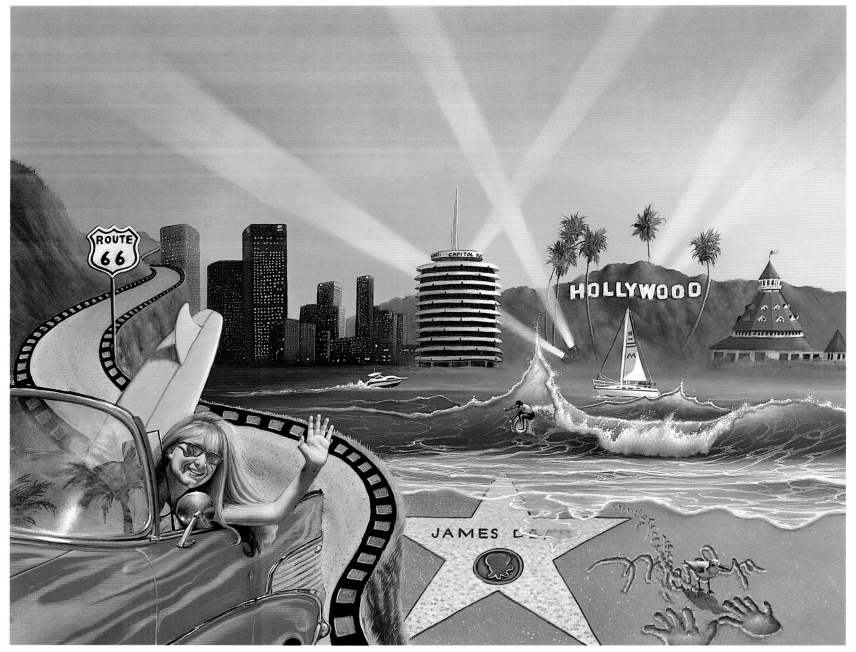

Southern California: with Fond Memories

1994

Jim's dad (wearing Mom's dress) modeling for "Aztec Indian" (right)

I usually have my friends and family model for my paintings because the poses I need are often so outrageous that no one else will do it. Sometimes while photographing on the front lawn, passersby or neighbors look at us, amazed at what they see, and ask, "What in the heck are you guys doing?"

Relatives modeling for "Night of the Living Dead" (right)

"Discover" Magazine illustration

Movie Poster

109

Ad for Bear Wailer clothing line 1988

(above & right) These photo-illustrations were done by gathering up a few friends and professional models and arranging them in a room according to my preset plans, and then photographing the scene. 16 x 20 prints were made from the shots, and then I painted the special effects directly onto the prints.

110

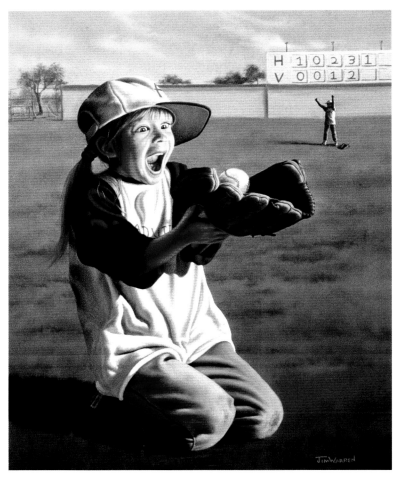

First Catch, 1993

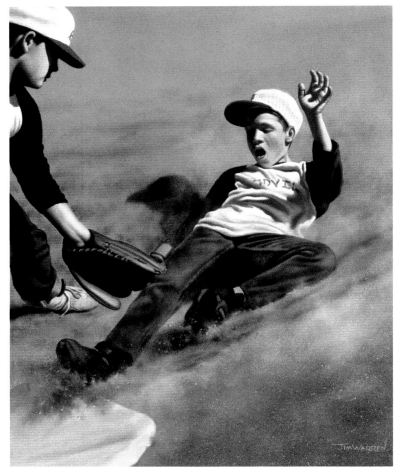

Safe at First, 1993

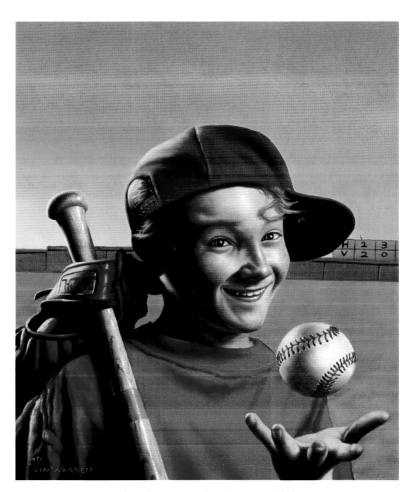

Random House book cover, 1993

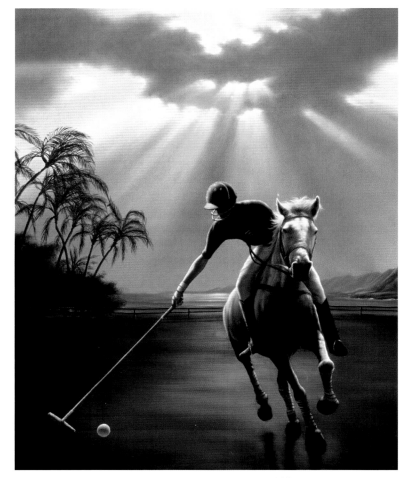

"Polo Hawaii" magazine cover, 1994

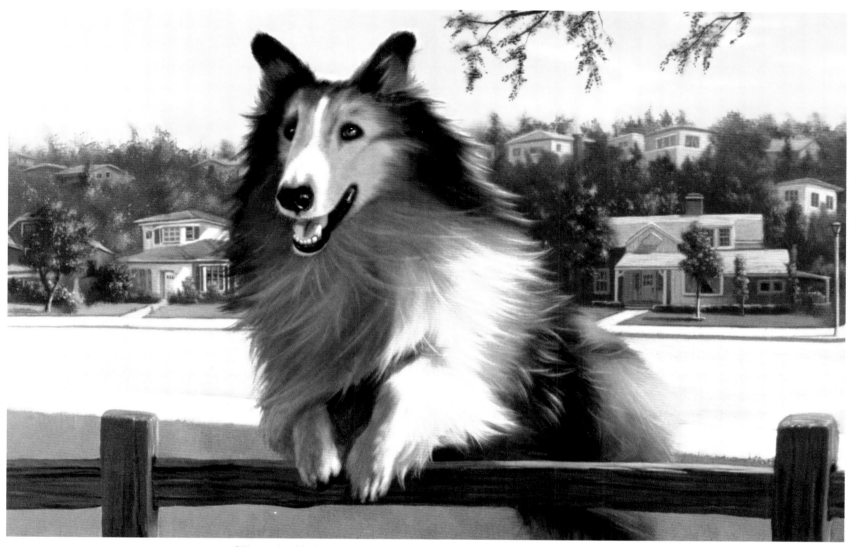

Billboard ad for Universal Studios advertising the new "Lassie" TV show, 1988

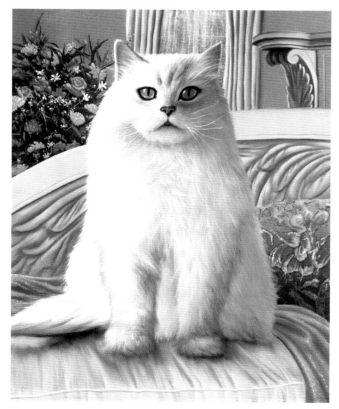

Fancy Feast cat food TV & magazine ad, 1990

Mazda ad 1990

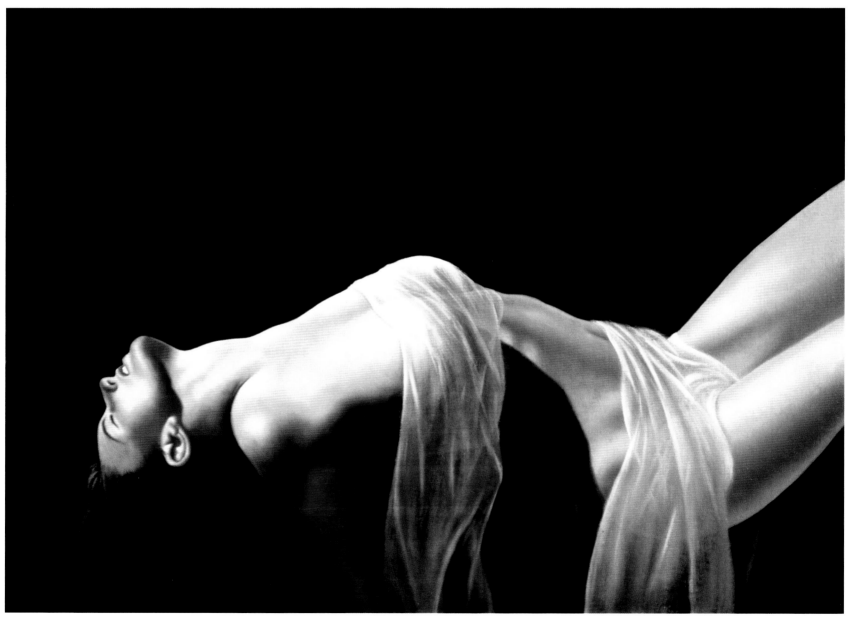

Movie poster for Edgar Allen Poe's "Haunting of Morella" (Light as a Feather) 1989

There's nothing like the first time...

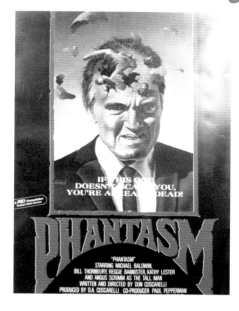

First Movie Poster – 1978

The star of this movie, Angus Scrimm, "the Tall Man," came over to my apartment so that I could photograph him for the movie poster art. He came with his movie make-up on, and my neighbors were a little curious, to say the least.

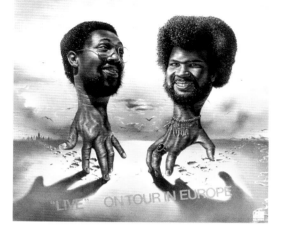

First Album Cover – 1978

To do this cover, I went to Hollywood to photograph Billy and George. We went out into the sunshine on Sunset Boulevard, and I had them walk their hands along the sidewalk for the pose. I thought to myself, "This is wild. Here I am, hardly out of high school, telling these two jazz greats to walk their fingers along Sunset Strip."

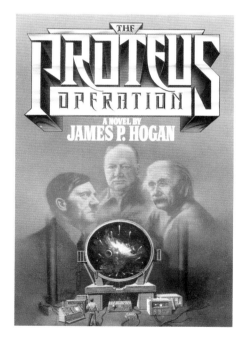

First Book Cover – 1987

When New York Art Representative, Alan Lynch, saw my work in 1987, he said he would give my art a "try" with the book publishing industry. He soon landed me the job for the cover of "The Proteus Operation" by James P. Hogan. This was the first of over two hundred book covers I've done with Alan.

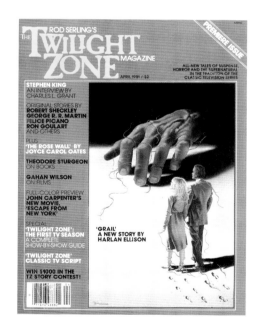

First Magazine Cover – 1982

When I was commissioned to do the first issue of Twilight Zone Magazine, one request was that I show the completed painting to flamboyant author, Harlan Ellison so that he could write a story based on my art. Visiting Harlan at his home in Los Angeles was an interesting adventure for me, a young artist, doing one of my first illustrations.

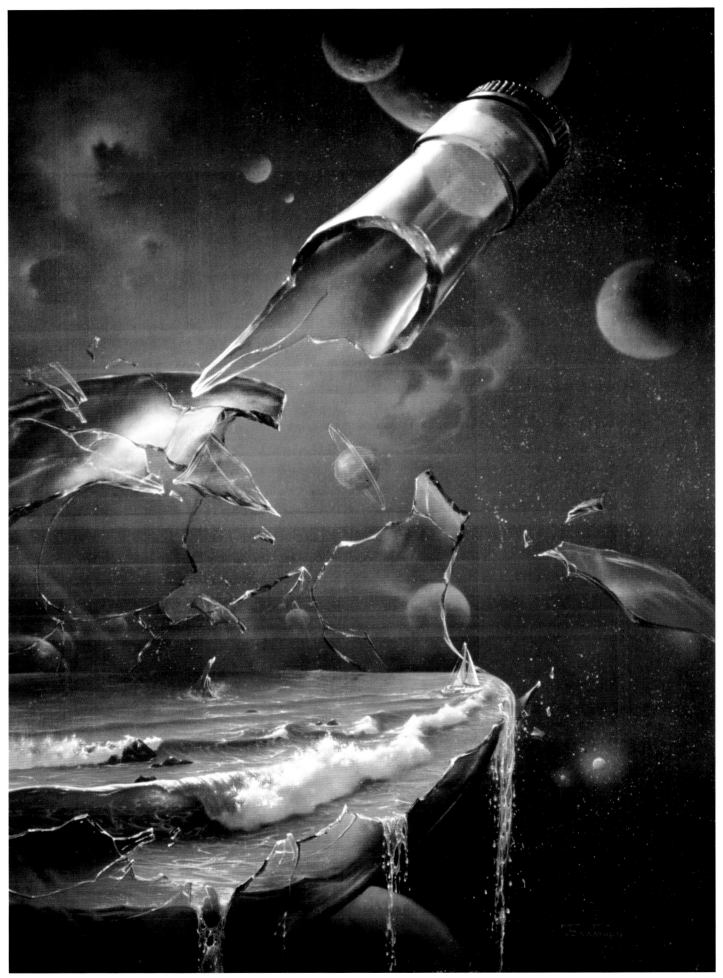

Book cover for Samuel R. Delaney's "Drift Glass," Signet Books 1988

My dad is a great model, except he always asks me, "How much am I getting paid to do this?"

"Discover" Magazine Illustration 1989

Jim discussing "Art as a Career" with students at
St. Cornelius Catholic School

Card signing

NBC News Clearwater, Florida, 1995

Cable TV interview, 1982

Jim ripping through canvas for NBC News
Halloween, 1995

Painting demonstration

NBC, San Antonio, Texas, 1996

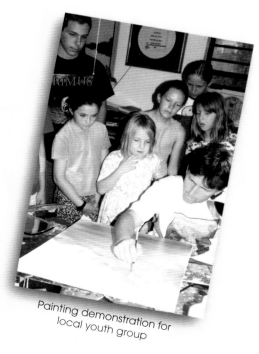
Painting demonstration for
local youth group

Card signing at Renaissance Academy

Jim Shares His Magic

I have shown my work at hundreds of art shows, at outdoor festival shows early in my career, and in more recent years at art galleries where people are invited to meet the artist. The purpose of these shows is to sell paintings, but I also meet aspiring artists. They sometimes ask my advice on everything from "how to make it" as an artist, to "How do you start painting in the first place?" I've been asked to teach, lecture and even write a "how to" book.

For years, I was reluctant to give advice. Being self-taught, I didn't want to share my "secrets," but even if it had been my purpose to teach others, I wasn't sure how to go about explaining to others what it is that I do. My career was built on instinct and intu-ition, and I had not had time to examine what had been successful that might be worthy of passing on.

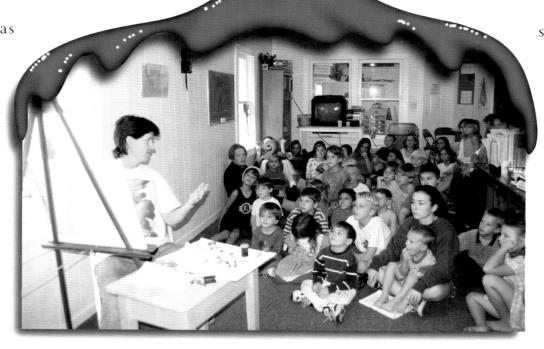

Painting demonstration for Renaissance Academy students, Clearwater Florida, 1996

In 1980, at an art show in Malibu, California, a nine year old girl waited patiently to talk to me. "She wants to be an artist," her father said, "and would like some advice from you." She looked up at me with big, wide eyes, as if she were meeting the President. I advised her, in a fumbling sort of way, about mixing paints, putting them on canvas and never stopping until someone notices your work. As I spoke to her, I realized that there was more to being a successful artist than just being "rich and famous."

As I became more secure with my own art and career, I became less shy about sharing techniques and ideas with others. This chapter of the book was written espe-cially for those of you who are aspiring (or failed) artists. At the suggestion of my fans, I have called it, "Jim Shares his Magic." I'm amazed that something which is so natural to me, is to others—magic. But, here it is. I hope it helps inspire the artist in each of you!

How to Stay Alive as an Artist

Paint because you love it

Some people love their job and some hate it. It is easy to recognize those who chose their careers because they were *interested* in the subject and those who chose their career because it was "practical." Because being an artist is not high on the list of practical careers, artists usually paint because they, simply, are driven to do so. And it is that interest, that drive to communicate an idea using paint and canvas, which makes a great artist. If you don't have that desire, painting will be a tedious, thankless task. If you do, and you let nothing come between you and that artist's heart that is within you, your life will be one of which most men only dream.

"If you look at the artists at the top of any field, you will see that they have one thing in common: they are each uniquely themselves."

Be Yourself

It's common for someone who admires an artist's work to want to imitate it. The first thing I tell any aspiring artist is, "If you want to be like me, then be you!" The single most successful thing I did to develop my style, was to be me. There were, of course, influences and inspirations, but every time I imitated another, I failed. Even if you succeed at imitation, you end up being an artist who paints "like" another. If you look at the artists at the top of any field, you will see that they have one thing in common; they are each uniquely themselves.

Paint from the heart

I once had an idea of a painting which was very exciting to me. On all sides were nature scenes which blended toward the center of the picture. The focal point was a woman with a blue face and red lips. I had never seen anything like it, so I knew it wasn't "popular," but I completed the painting. And, it sold fast. I called it, "Mother Nature." This was at the beginning of what I call my "Blue Face Period." I did several of these, and they were all successful.

Painting from my heart is what kept me inspired and my career exciting all these years. If I'm bored with a subject, my finished painting will reflect that. I always tell people, "If you're not interested in a subject, don't paint it. Find something you *are* interested in, and you'll see the difference."

Perseverance

There are many hurdles on the road to becoming a successful artist. The mound of rejection letters I've received could be used to wallpaper my house. I've been frustrated to the point of smashing paintings and heaving my brushes and paints out the door, off the balcony and into the yard, all accompanied by a loud, "I quit!" The next day, I woke up, recovered my paints and brushes and continued painting.

I have often thought that it was my ability to rebound from these moments of frustration which made the difference in my career. Many of the people I meet say, "I used to paint, but I quit. I wasn't very good." When I hear them say that, I think to myself, "Well *that's* not the time to quit! You need to keep working at it until you *are* good." *Perseverance* is the key to success. All the failure, rejections, obstacles and, even uncertainty are just hurdles which give the game excitement and challenge. No deep magical philosophy here, just the same thing I tell my kids when they trip and fall, "Go ahead and cry, get up, brush yourself off and then keep going."

Have a Career and a Life, too.

When I first experienced rapid success, a strange phenomenon occurred. I became self-absorbed, self-interested. Creative activity requires a great deal of attention, and my whole world became that which I was creating on the canvas. I began to take myself too seriously and forgot about the things and people that made being successful worthwhile.

When I was a kid in Long Beach, my grandparents were our backyard neighbors. After school, I came home and headed straight through the gate to play with Grandpa, my best friend. As I grew older and more interested in painting, my visits with him fell away to nothing.

Years passed, and my career became all important.

In 1968, my parents called to tell me that Grandpa had died and to ask me to go to the funeral. I told them I was too busy with my painting to attend.

Over the years, there were other relationships which I neglected as I fought my way up the ladder to success, and later I looked around and realized that, despite the attention and popularity I was enjoying, something was missing. I had built a career but had forgotten to build a life! Success alone, I found, was empty.

"I had built a career, but had forgotten to build a life."

I learned that people are not distractions and that isolation from friends and loved ones is destructive to the heart of the artist, because an artist provides himself with inspiration through his love of life and of people. When you allow your personal life to fade, it's as if there's nothing of value left to paint.

I'm glad I finally realized this, as I have a great family life because of it. I now find myself "hanging out" at Chuck E. Cheese (with the kids, of course,) and actually enjoying it. Or my wife and I might pile everyone into the van to go out to eat, browse the mall, or go to the beach, while completely forgetting the demands of my career.

I still slip sometimes, though. While being with my four year old daughter, I have drifted off in thought. She asks me a question, and I answer, absent-mindedly, "Yes, Drew." She looks at me quietly and says, "Is that a *real* yes, Daddy?" Nothing like children to keep things in balance.

Jim at play with his children, Drew and Art, and grandchildren, Chris and Clover

Drew, Art, and Cindy

My family

121

Take a Break

This is not a new concept. Everyone takes a break of some sort, and it's so important that it is law in the public workplace. But sometimes, particularly when you are wrapped up in what you are doing, you may decide that you don't have time. Or you spend your "break" thinking or worrying about the very thing you are trying to get away from for a moment.

As an artist, I find taking a break invaluable. When I find myself stuck in what I call a "painter's block," I force myself to stop, put my brushes down, get away from the demand of the canvas, and do something else. When I'm away from my work, the creative blocks float away, and my best ideas for a painting flood in. They most often come to me when, or after, I do something I really enjoy.

The beach has always been my personal favorite for this, and not because it's a nice place to go to think. But, because it's a nice place to *not think!* Maybe it's my California upbringing. But I love the sun, surf, the open space, and the friendly people. It not only gets me away from my studio mentally and physically, but getting out and living life is what fuels my imagination.

Constructive vs. Destructive Criticism, or How I Choose My Associates

I realized early in my career that being an artist put me in a vulnerable position. There I was, my heart and soul on display for all to view, to comment on, to criticize. As with most artists, I've had criticism and I've had praise. Fortunately for me, my art has almost always been very well received. But, I've noticed that there are two distinctly different types of critics: those who make an honest attempt to help, through "constructive" criticism, and those who attempt to drive an artist under. The latter are the guys who seem as if they're at a carnival playing, "Hit the bullseye and dunk the clown!" After getting soaked a few times, I toughened up and remembered that my first goal as an artist *was* to "make waves" in the art world. So, why should I be surprised if I got a little wet while making waves? Further, I thought, there *is* one way for me to completely avoid criticism: Do *nothing!* Clearly, I was not going to sit still while my artistic dreams died. So, when the criticism comes, I take it in stride and continue painting.

Another area entirely, in which I am not quite so forgiving, is in dealing with my business associates. This is for the simple reason that they are so close to the creative process itself, so close to me. If I find that a business associate is making me feel discouraged or inadequate, then it's time to say, "Move on!" My peace of mind and quality of art depend largely upon surrounding myself with people who support and care for me.

Jim Warren's studio (http://www.jimwarren-art.com), Clearwater, Florida

Photography

Some artists use live models, some use only their imaginations, but with the realistic style of art I use, photography is a much needed tool, like paintbrushes and canvases. As with painting, for the most part I am a self-taught photographer. I have studied several books on the subject, all of which you can get from libraries, bookstores or camera shops. Because it has been successful for me, I feel it is best to experiment and find your own natural style. For example, what pose do you like best? What lighting, expression, and what type of model depends on the style of art you're using.

Except when shooting for portraits, I rarely use photos as they are. I use them mainly for reference. I alter them as I sketch to achieve the effect I want, varying from one painting to the next. Even when doing portraits, I often take twenty to thirty photographs and combine them as needed to create the final image. For example, I might mix a head shot from one photograph with the body pose from another picture, or use an arm from one shot and other parts of the model from another. (Yes, it's a little like playing Dr. Frankenstein!)

Sometimes, I even use different parts of the face. I might like a particular face angle, but maybe the eyes were closed, so I would search the series of shots for one where the eyes are fully open, and then use the combination of these two photographs for the first sketch. As with all photography, the lighting I use for my paintings is very important, so I might mix and match, also, depending on poor lighting in one photograph and excellent lighting from another.

The guideline I use for the look I am trying to achieve with photographs is the actual personality and character of the person. This is achieved by observing the person and getting to know them during the shoot. The person is very much on my mind throughout the whole painting process. (There is more information on this in the chapter on portraits.)

When taking pictures of my finished paintings (for use in promotion or reproduction,) I always take the painting outside midday and photograph it there. If you use this technique, be sure that the painting is positioned so that your finished photographs will be free of glare from the sun.

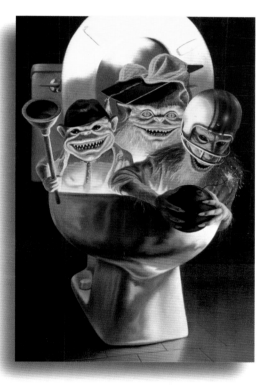

"Ghoulies Go to College," movie poster

Photos of Jim and nephew, Ryan, as ghoulies

Preserving your finished work

I regret not having kept photographic records of all of my early paintings. Photographs come in very handy for use in promotion, reproduction, or simply keeping a history of your work, or for use in publications such as this book, for example. Make a habit of photographing your works.

Publishers, agents, and magazines will most often prefer slides of your work. As I usually send prints, rather than slides, to my private clients and keep a set for myself, I use both slides and print film.

In some cases, a publisher may want a large reproduction of your painting to use in making posters or limited edition prints. To accommodate this, professional color labs can make what is called a color transparency which is like a large slide.

When you are ready to invest in color transparencies, look for a professional color lab in the yellow pages, contact another professional artist friend, or check with a local gallery owner who should be willing to refer you to a reputable color lab.

Models

The models for my paintings are most often people I know: friends, family, neighbors, even I, myself. When doing an illustration, I am usually given a description of the characters that will be depicted. In a fiction book, for example, the characters are most likely to come directly from the author's imagination and can sometimes be out of the ordinary. I try to find someone who fits that description as much as possible, and then alter the face or clothing during the sketch phase until I have achieved the look that's needed. I often feel as if I am on a scavenger hunt, looking for a "curly-haired, ten year old girl in a flower print dress and red snow boots."

Cameras

As with all other facets of my career, I discovered my favorite camera through experimenting. My preference, due to the ease in using it, is the Minolta Maxxum. Working with it, all I have to do is see my subject, shoot and develop.

As outdoor lighting is sometimes too bright for the model's eyes, I prefer to use indoor lighting. Most often, I use a halogen sun lamp, but sometimes I use the lighting through a window or door. I have used whatever light is available in some situations, but camera stores have any quality of artificial light you might want. No matter what is available, I experiment with different lighting until I see what I want, then I shoot. These are just the basics and what I have found that works for me. Everyone is different, and you should experiment with this until you get the look you want. And, if you are like me, perfection will probably

Friend, Curtis, and nieces, Cristin and Briana, models for "Whale Rides"

never come because each time I feel I am close to the exact formula, I think of something else I could do to make it even more interesting. But you will never stop trying to get a photograph more perfect than the last. It's just the nature of an artist.

Shooting Scenery

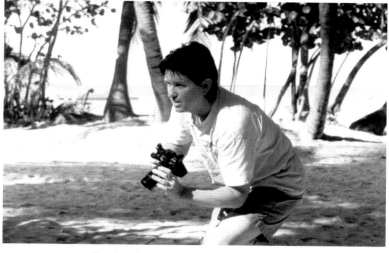

Jim shooting scenery in Key West, Florida

"…Mother Nature is my favorite art director."

The scenery in my paintings is often made up from my imagination, as there aren't many places I have seen that are quite as interesting as I'd like them to be. Although Mother Nature is my favorite art director, I do take artistic license to create environments of my own.

I often carry a camera with me to photograph an interesting tree, a beautiful Florida sunset, or anything else that catches my eye wherever I might be. As with the pictures I take of models, I might take parts of one place, mix them with parts of another, add a little imagination and create my own unique setting. This works well with my fantasy style of painting. Other times, I might simply paint a specific scene from some place, like the California surf or a Hawaiian sunset. Many artists specialize in painting particular areas of the world.

Just as I do when painting a portrait of a person, while I'm photographing scenery, I keep in mind the mood and character of the location. There is a spirituality that comes from nature which stays with me as I paint it on the canvas. I am constantly observing things around me. Reflections on ocean waves, the way shadows fall across other surfaces and change colors at different times of the day, and countless other details.

The mind's eye is the best tool the artist has, but the camera can also be a handy tool which we can use to catch, in one still moment, the shapes, forms, light and shadows given to us by Mother Nature.

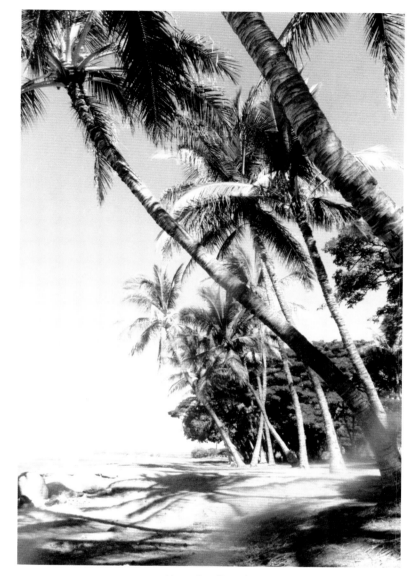

Hawaiian Beach

Technique

Although I have done demonstrations for inspired friends and groups of school children, I had been hesitant about teaching anyone exactly what I do. Not for fear of competition, but because I believe painting techniques and style are personal things and are best when discovered naturally by the artist himself. Being a self-taught artist, what really worked for me was to just get in front of the canvas and start experimenting.

But I do feel that it's important to learn some basics. Although I failed my high school art class, I remember some things my teacher taught us about balance, colors, observing one's environment, lighting and shadows. (Yes, Mrs. Gotto, that rebellious, know-it-all kid in your class *was* paying attention after all. Can you raise my grade a little now?)

"I've heard people say that artistic ideas develop only in dreams or, worse, in a drugged state."

Two other sources of enhancement to my own natural style have been books by other artists who have shared their "secrets" and the great masters.

Detail (actual size)

Ideas

The question I am most often asked is, "Where do you get your ideas?" The answer is as simple as they come: my imagination. It's my most important artistic tool.

I've heard people say that artistic ideas develop only in dreams or, worse, in a drugged state. This hasn't ever been true for me. Just observe children at play. While awake and clear-headed they can entertain themselves for hours, with only their imaginations.

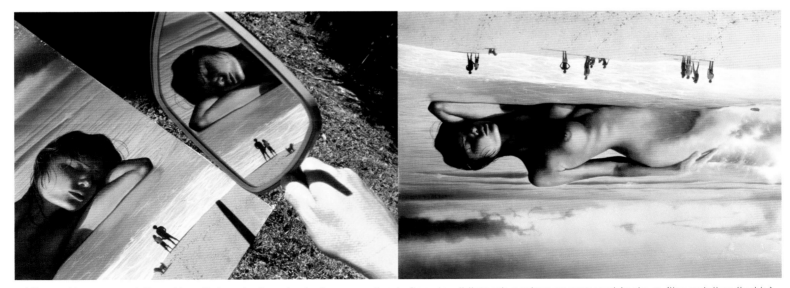

After working on a painting at length, in order to get a fresh perspective, I often view it through a mirror, or even upside down (the painting, that is.)

126

The alert eye, observation, and imagination are some of our finest and most important resources as artists.

Sketches

Sketching is a lot of fun, but it is also an important tool for developing a new idea. Somewhere between inspiration and painting is the sketch. I simply start with a pad of white paper and a pencil.

Before I begin a painting, I ask myself, "What type of picture do I want to create today?" (For example, romantic, environmental, dramatic or serene?) When

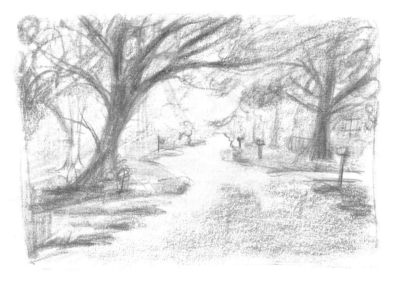

Original sketch for "Country Lane"

that's decided, I begin by sketching on an blank sheet of white paper. It is on this page where that inspiration is brought to life. I find that ideas just seem to flow from the empty world of that blank, white sheet of paper.

With my initial sketch, the subject matter is very loose, almost abstract. In this earliest stage, I design and balance the subject, and sometimes create color combinations as well. Though this sketch looks like scribbles to anyone else, it is my main reference piece throughout the entire painting process.

When I move the sketch from paper to canvas, the original loose design is tightened up for my final, more realistic painting. Occasionally, when doing a realistic subject, in particular a portrait, I use what is called an opaque projector to get an exact likeness of the subject. In illustration, the projector is used often but is somewhat frowned upon by fine art instructors. Some consider its use cheating and prefer to draw the subject as it appears in front of them, according to their own

creative interpretation. I agree with this method, particularly in painting abstract or impressionistic styles. The few life drawing classes I have taken were helpful in developing my loose, creative sketching style. However, my attitude toward my finished paintings is to do whatever it takes to achieve the effect I envision.

Final sketch for "Against the Wind"

For an art director or client who wants to approve a sketch before I proceed with the painting, I do a second sketch which is much tighter (realistic.) This is done on a better grade of paper and in black and white or colored pencils.

Regardless of how great I think an idea is in the beginning, I never know if it is really worth painting until I put it through my scribble test on plain white paper. Many are drawn. Few actually make it to the finished canvas.

On the following pages is the step-by-step process of one of my paintings. What is shown here is what I, myself, do to achieve the effect according to my own style. It is neither the only technique, nor, necessarily, the best. You need to *experiment* to develop your own techniques to find what works best for you.

(This is not a how-to lesson, as that would involve a whole book in itself—possibly even a video or personal instruction. These are just the basic steps I use.)

Jim demonstrates his technique step by step...

The subject for this painting is one of my favorite actresses, Juliette Lewis.

1. After I have an idea in mind, I position my subject with the desired lighting.

2. I take many photographs using different lighting setups and positions. For nature scenes, I often use only my imagination.

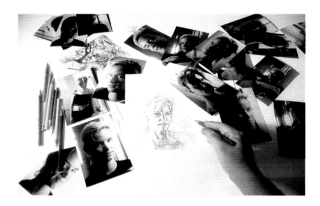

3. I draw sketches in pencil based on the photos that I find work the best.

4. To prepare my canvas for a smooth surface, I use two coats of gesso primer and then sand it after it dries for a day.

5. I sketch my final idea onto the canvas with a pencil.

6. Similar to painting a car, I do a loose under-coating in acrylic water color. This gives my final oil paint a richer look, and it obscures the pencil lines which can show through the final oil paints.

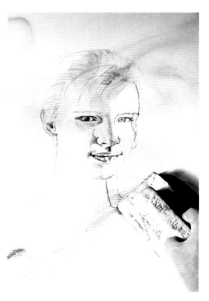

7. On a paper palette, I mix my colors with the desired amount of linseed oil. (Partly due to health considerations, I don't use paint thinner to mix paints. To avoid paint fumes, I use precautions, such as industrial (or window) fans, and I spray lacquers outside in the open air.

8. I lay the paint down loosely in the area I am working on. (Note: No air-brushing is used in any of my paintings).

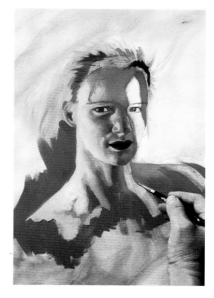

9. To achieve the smooth, brush stroke-free effect that I use most often, I blend colors with a soft brush. To keep my brush semi-clean while blending, I wipe it often on a lint-free rag. (This also eliminates the need for paint thinner, which I've seen artists continuously use while painting).

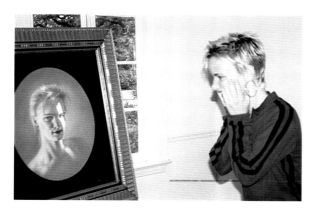

10. Details make the painting really take shape, and are my last step. After the paint has dried, I use a small-tipped brush to paint such things as hair, clothing patterns, ocean spray, etc. I also bring out the highlights and darken some shadow areas. When all paint on the canvas is dry, I take it outside and spray it with a coat of Kamar varnish.

11. The unveiling.

12. Happy client.

"Jim's art is like none I've ever seen. The power and imagination in his paintings and portraits are indescribable. They move and inspire you. I love them. Everything he does is different and amazing. He is amazing!"

Juliette Lewis

The Business of Art

Gallery window signing, Las Vegas, 1996

Promotion

From the start of my career in 1967, my goal was to become "The Greatest Artist the World Has Ever Seen." I worked very hard at producing great paintings, often into the wee hours of the morning. It wasn't long before I realized that in order for these paintings to be seen by the world rather than gathering dust in my storage bin, I was going to need to get familiar with another completely different but equally important subject: promotion.

Being involved in both fine art (galleries) and illustration, I get asked many questions by aspiring new artists: "Where do I find my contacts? Where do I show my work? How do I find agents, representatives and art directors? What do I send them?" and, "Is it expensive to get started?"

I started in this business with the simple attitude that if my paintings really communicated and were of high technical quality, that they would sell. All I would have to do would be to show them to somebody.

Therefore, in 1980 I took a trip to a nearby music store and went through record covers, looking on the back of the cover for the names and addresses of the art directors for each company and jotting them down. I collected a few photos of my best paintings and wrote a letter to each company saying, "Dear Art Director:

Enclosed are samples of my work. I am interested in doing album covers for your company." I, of course, included my phone number and return address. With some, I got no response; with others a form letter saying they couldn't use my work. But, sometimes, I did get called to do work for them.

One of the companies I wrote to was Capitol Records. I had called information in Los Angeles to get the name of the art director so that at least my letter had more of a professional ring to it, rather than just, "Dear sir." For months I had no response from Capitol and was convinced that my letter and photos had been thrown out.

A year later, the art director from Capitol called, said he had the photos I had sent, and hired me to do the cover of Bob Seger's "Against the Wind" album. All it took was a few photos and a stamp. Getting your art known on the market can be just that simple.

Companies which produce greeting cards and posters can be contacted in the same way. Names of galleries can often be found in art magazines, in your local book store or in the yellow pages, all of which can be found at a library. Lists of art directors, design studios, and artist representatives can be bought from illustration guides such as "The Workbook" and "American Showcase." These can be found in most art supply stores. Another search method available now is, of course, the Internet.

Some people feel that quality of presentation is the most important factor when they send out promotion. Although a good presentation is important, expensive promotion, especially in the beginning, is not always possible. Because of the success I've had with simply sending out photos in the mail, I feel that if the art is of high quality, people will overlook the simple, inexpensive way it's packaged. After the first successes, money can be invested in more elaborate promotional items such as color brochures. You can also place advertisements for your work in illustration annuals which are sent to art directors all over the country. The increased promotion of your art work should certainly result in even greater sales.

Contracts

On the subject of contracts, there is just one simple rule: Don't sign anything you can't live with!

> **For months I had no response from Capitol Records and was convinced that my letter and photos had been thrown out.**

Agents, Artist Reps and Publishers

To understand this part of the art business, an artist should know what agents, artist reps (representatives) and publishers are.

An agent is a person who has been given the authority to do things for an artist. The term, "agent," is usually associated with fine arts. Artist representatives are agents in the field of illustration. As I paint both fine art and illustration, I work with both an agent and an artist rep. If your work is strictly illustration, then you would only need an artist rep. Before hiring an agent or artist rep, you would work out an agreement which would define the services he would do for you.

A publisher in the art business, aside from the more common meaning, is, simply, a person who makes something "public." In other words, your publisher should be promoting your work and making it known to the world.

When I speak to new artists about promoting their work or becoming successful, I make it sound as if it's so simple that anyone could just do it themselves.

Why would anyone need an agent? Well, it can be simple, especially in the beginning, just as I first promoted my work, using letters and photographs. But what do you do once your work is known and several different art directors are calling you, and they begin to talk about contracts and such? Remember, you will be talking to them and arranging agreements and so forth during the time when you used to paint. Who's going to be painting your pictures when you are on the phone with those art directors?

Once you get enough of these calls, you might wish that you had someone to handle these things for you. And that someone is the agent, artist's rep or publisher. With these carefully chosen people on the job, you can get back to doing what you wanted to do from the beginning—paint!

The other choice is to study these subjects yourself and, even more important, get experience in the area, which takes time. A successful artist usually doesn't and probably shouldn't have the time to deal with these facets of the art business.

However, if for some reason you have learned the promotion end of the art business enough to correctly handle it, then, as you become more successful, you will probably benefit from a good business or office manager along with any other personnel you feel could help manage your affairs, such as a good accountant.

Handling one's own promotion is a large responsibility but if an artist feels he needs to be in control and is capable of doing so, it can work. After having years of promoting my own work and years of using agents, artist reps and publishers, I have concluded that the business side of art requires equally as skilled, talented and experienced professionals as the artist himself. It's a little like a race-car driver and his mechanic—one doesn't get far without the other.

When choosing an agent, artist rep or publisher, office manager or accountant, think of it as a partnership or a marriage. Get to know the person you are considering for the job *before* you get "married." Your goals and those of your publisher, for example, should be similar. If you like to illustrate children's books, and the artist's representative you are considering is a specialist in corporate advertising, you probably won't have much of a working relationship.

"Get to know the person you are considering for the job *before* you get 'married'."

Along this same line, look for someone whose skill and experience level is similar to yours. An established and successful agent, well versed in business negotiation and equipped with hundreds of contact, will be frustrated trying to assist an artist who is not ready for grand scale promotion. Similarly, an experienced and accomplished artist would be quickly discouraged by a new publisher who was less than eager to go out and enthusiastically promote the artist's work.

And, of course, you don't want to hire anyone who drags you or your work down, no matter how brilliant they may sound or how stellar their reputation. Remember, you're not hiring a critic. You're hiring someone to help forward your career, get your work out into the world, and get money into your bank account.

On the following three pages are some of the magazines, newspaper articles, and assorted products produced from my work.

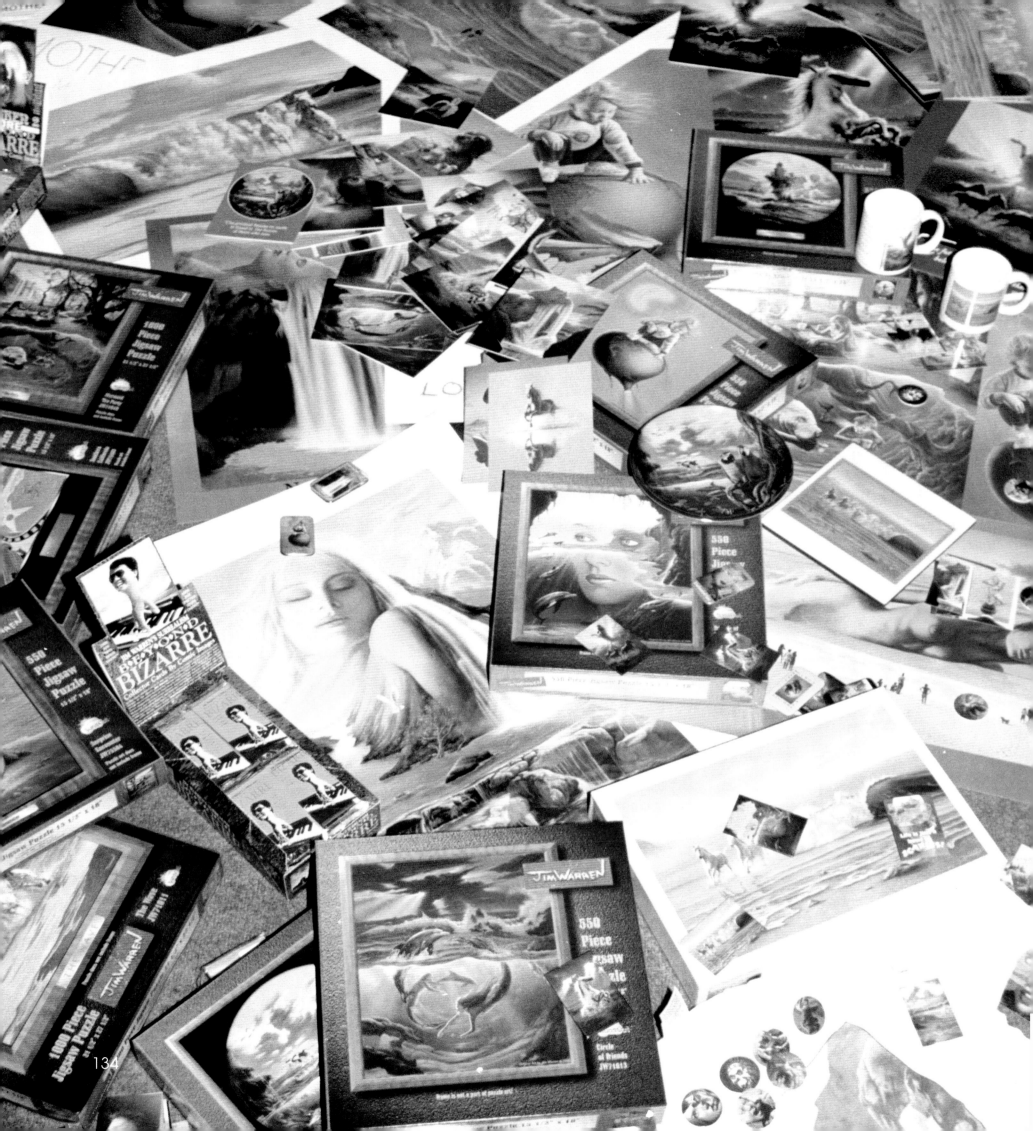

134

I believe that in each of us, there is an artist who
may, like the dinosaur, have become extinct.

I hope that in some way, large or small, this book
helps to inspire, to bring back to life, that artist
once again, to roam the earth and create art,
if for no other reason than to simply have fun.

Until my next book, farewell!